IMAGES
of America

CASTRO VALLEY

IMAGES
of America

CASTRO VALLEY

Lucille Lorge, Robert Phelps, and Devon Weston

7

Published by Arcadia Publishing
Charleston SC, Chicago IL, Portsmouth NH, San Francisco CA

Printed in Great Britain

Library of Congress Catalog Card Number: 2005930106

For all general information contact Arcadia Publishing at:
Telephone 843-853-2070
Fax 843-853-0044
E-mail sales@arcadiapublishing.com
For customer service and orders:
Toll-Free 1-888-313-2665

Visit us on the internet at http://www.arcadiapublishing.com

CONTENTS

ACKNOWLEDGMENTS

We would like to extend our thanks to the diverse group of individuals who assisted in the preparation of this work.

To interpret the photos, we drew on the combined wisdom of past chroniclers of Castro Valley history, notably John Sandoval, Harwood Hall, Banning Fenton, M. W. Wood, and the combined "Eden Writers," to name just a few. Much appreciation also goes to the staff of the Hayward Area Historical Society, not only for granting us access to their superb photographic collection, but also for providing us with their expert knowledge regarding the history of Castro Valley and its neighboring communities. We owe special thanks also to HAHS archivist Diane Curry and museum volunteers Bernie Golumb and Amy Kidwell for their insight and assistance.

We would also like to thank the following institutions, historical professionals, and local residents for sharing their knowledge, expertise, and personal memories of life in this special community, especially Joyce Adams, Arnold Anderson, Jacqueline Beggs, Jerry Bishop, Rita Blake, the Castro Valley Autohaus, the Castro Valley Chamber of Commerce, the Castro Valley Forum, the staff of the Castro Valley Library, the Chouinard Winery, Kimberly Clark, Ann Duey, Eden Medical Center, Jeanie Davilla Ferguson, Phyllis Davilla Fields, the Hanson Family, Shirley Heger, Herb Huber, Edith Gunn Jensen, Katherine Kaye, and Clara May Krch; Steven Lavoie and the Oakland History Room; Betty Ray Lesch, Clyde Lyeria, and Doris Marciel; Paul Merrick and the Dunsmuir Ridge Alliance; George Miller, Nancy Summerlin, and the CSUEB Anthropology Department; the C. E. Smith Museum of Anthropology; Al Nunes; the staff of the Oakland Public Library; Bobby Peek and Woody Pereira, Sally Prince, Dee Roberts, Ruth Brillisoup, Paul Salvadorini, Wilma Salomish, Erma Smith, Ann Sorensen, Bob Waberski, Dick and Annette Warren, and Gary Zimmerman and the Fairmont/Lake Chabot Ridgelands Committee.

Finally, this book is dedicated to the memory of Ray C. Lorge, late husband of Lucille Lorge; to Banning Fenton, past historian of the Castro Valley/Hayward Area; and to all our family and friends.

INTRODUCTION

In 1852, Father Zachariah Hughes purchased a 500-acre parcel of land in what was then called Castro's Valley, a crescent-shaped basin named for the militia officer awarded the 27,000-acre land grant by the Mexican government. For two decades, Don Guillermo Castro fattened his cattle herds in the green fields of the valley. Now, plagued by drought, squatters, and appalling luck at the gambling table, Castro was selling portions of his holdings to immigrants arriving in the wake of the gold rush. With the sale, Hughes became the first American to settle the basin on the north bank of San Lorenzo Creek.

A Methodist minister, Hughes decided to build a small redwood structure that could double as a schoolhouse and community church. For almost a decade, the one-room building, christened Eden Vale by Hughes, served the population of Eden Township in the new County of Alameda. Although Eden Vale was located in the Crow Canyon section of Hughes's property, most of the students came from outside Castro's Valley. Every school day, roughly 50 children walked over a mile to attend class at the little school, a practice that required the regular fording of San Lorenzo Creek.

Yet by 1864, promoters and parents in Haywards, a fast-developing town on the south side of the creek, decided to end their children's regular trek. Having no funds to build a school of their own, they looked north to Hughes's tiny academy. The valley and the canyons surrounding it were, after all, an illogical place for a school: the area was less populous, less urbane, and, politically at least, less organized.

Late one night, a committee of Haywards promoters crossed San Lorenzo Creek, armed with planks, rope, jackscrews, and, ominously, a single wagon. Together these self-appointed activists pried Hughes's school off the canyon floor, lifted the structure onto their transport, and promptly wheeled it over the muddy track south to downtown Haywards. Castro Valley had lost its first school to a larger, better-organized neighbor.

Undaunted, within two years valley residents built a new facility they christened Redwood School. Located on the corner of what is now James Avenue and Redwood Road, local ranchers built the schoolhouse and paid teacher's salaries out of their own pockets.

The story of Eden Vale and its rapid replacement by community action in many ways mirrors the wider history of Castro Valley, a region both intimately connected to and unusually secluded from its surrounding neighbors. Enclosed by the San Lorenzo Watershed and a series of rolling hills, the valley also sits astride a natural cross-section of canyons carved by the watershed's tributaries. The combination paradoxically isolates the area from other communities, while giving it ready access to natural pathways of travel. This geographic contradiction in part accounts for the fact that Castro Valley remains one of the most populous unincorporated areas in the United States. Isolation guarantees a distinct and enduring community identity. Connection means that residents can seek the occasional advantages of urban life elsewhere, allowing them to maintain the rural flavor and small-scale politics of the valley they call home.

Of course, Castro Valley's history did not start with the building of Eden Vale. The Ohlone were the first to inhabit the region, using the rich natural environment to sustain their ancient way of

life. The arrival of the Spaniards in what they named Alta California in 1769, their replacement by Mexican authority in 1821, and the subsequent division of Guillermo Castro's holdings after the gold rush, all brought a succession of important historical changes to the East Bay in general, and Castro Valley in particular.

Yet geography ensured that change would come slowly to Castro Valley. Physical barriers meant that intensive agriculture and urban development would find other homes in the decades immediately following the gold rush, while Castro Valley had only scattered ranches, orchards, and farms owned by a few pioneering families.

While the rolling hills and winding creek conspired to lead the mass of early settlers in other directions, Castro Valley was, however, perfectly suited to poultry. The hills enclosing the valley floor served as a shelter against chilling bay winds that might be terminal for a relatively fragile pullet. By the 1920s, Castro Valley was on its way to becoming one of world's leading centers of poultry production, with over 800,000 chickens greatly outnumbering the community's 2,500 residents.

But those residents had dreams. Annexing their properties to the East Bay Metropolitan Utility District in the 1930s, Castro Valley's human inhabitants gained access to a water system that could pave the way for future expansion. Their timing couldn't have been better. World War II changed California forever with a massive influx of migrants and the development of an industrial economy second to none. That, and the subsequent postwar "baby boom," created a housing shortage throughout the region and pressure to commit open lands to residential development. Castro Valley's population increased by some 400 percent in the 1940s alone, the once sleepy valley becoming ever more covered by endless rows of houses occupied by families eager to escape increasingly crowded cities like San Francisco, Oakland, and Hayward.

Today Castro Valley supports a population of some 50,000 and the community, once home to a handful of businesses, is now a major commercial center. The 580 freeway and other thoroughfares cast the region in its modern role as a bedroom community serving one of America's greatest megalopolises. But the valley's past is still preserved in the ranches and lush grazing lands of its neighboring canyons and hills, in its endless debates between incorporation and independence advocates, in the preservation of its associated Lake Chabot, and in a famous rodeo held every May, heralded by an annual parade down the community's cherished Boulevard.

One

ORIGINS
PRECONTACT TO 1900

What eventually would be called Castro Valley was originally inhabited by the Ohlone, a group of hunter-gatherers who utilized resources provided by the rich natural environment of the region. Their social structure was based on family alliances, forming small bands of approximately 250 people.

When the Spanish colonials established permanent settlements around the San Francisco Bay in 1776, many of the Ohlone were brought to nearby Mission San Jose, their lands distributed among settlers of Spanish or mixed heritage. In 1821, however, revolution delivered California to the new Republic of Mexico, which continued Spain's policy of populating frontier territories by the distribution of land.

Among the local grantees was Guillermo Castro, who was awarded 27,000 acres around San Lorenzo Creek in gratitude for his service as a San Jose militia officer. There Castro engaged in the lucrative export of hides and tallow, using the valley on the north side of the massive ranch that he christened Rancho San Lorenzo Alta as a winter grazing area for his rapidly expanding herds.

The United States acquired California in 1848, but despite promises that prior property ownership would be respected, Mexicans landowners were soon overwhelmed by a flood of American squatters, disappointed by the quickly depleted California gold fields. Castro himself was forced to sell his holdings to cover his debts, and by 1870 the old Don was gone, replaced by settlers with names like Hughes, Stanton, and Strobridge—all busily developing the place they now called Castro's Valley.

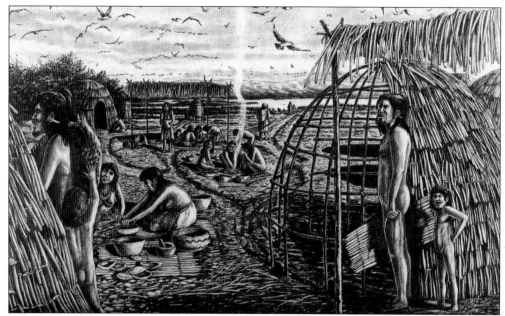

OHLONE INDIANS. An Ohlone man constructs a tule hut in a village setting. Two Ohlone bands, the Jalquine and Seunen-e, lived in the area of Castro Valley. A permanent native village was once located in the hills behind Fairmont Hospital, its existence evidenced by the remains of an Ohlone cemetery. (Illustration by Michael Harney from *The Ohlone Way* by Malcolm Margolin; courtesy of Heyday Books.)

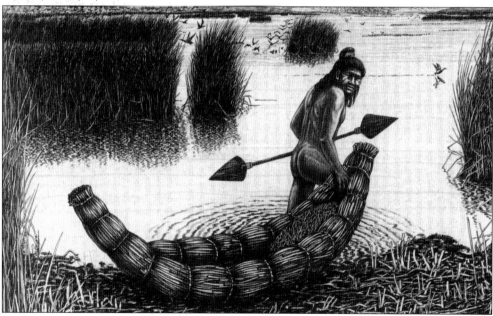

TULE CANOE. An Ohlone wades in the water with a canoe of tule rushes. Native shoreline activities included fishing, gathering oysters, and collecting salt from driftwood and rocks to trade with other tribes. The Ohlone also relied on the San Lorenzo Creek Watershed for their everyday needs and freshwater catch. (Illustration by Michael Harney from *The Ohlone Way* by Malcolm Margolin; courtesy of Heyday Books.)

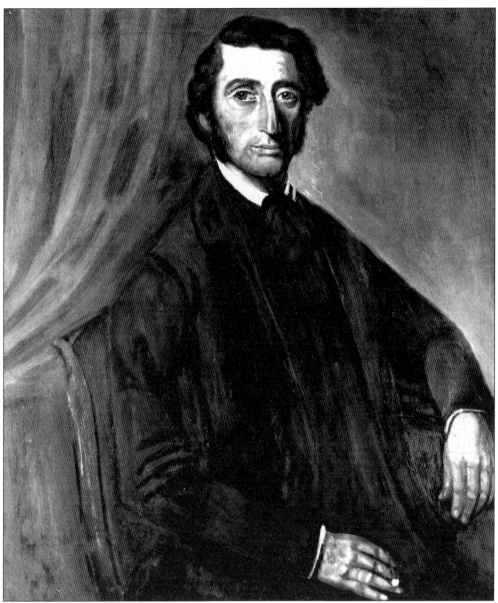

GUILLERMO CASTRO. After the first Spanish-Ohlone contact during Lt. Pedro Fages's 1772 exploration and Capt. Juan Bautista de Anza's expedition in 1776, natives were brought into Mission San Jose and European inhabitants spread through California. Born in 1910 on his father, Joaquin Isidro Castro's, Rancho de Las Lagas near San Jose, Guillermo Castro served as a lieutenant in the pueblo's militia company, later becoming San Jose's public surveyor. In 1829, he married Maria Luisa Peralta, daughter of Luis Peralta, owner of Rancho San Antonio in present-day Oakland. The couple had seven children that included four boys and three girls. The Castro family moved to the Hayward area in 1839, building their adobe home near the present location of Hayward's old city hall. Gaining full legal title to the surrounding lands from the Mexican government in 1840, Castro chose the site for several reasons: he could water his extensive cattle herd on the San Lorenzo Creek; the area was linked to other Mexican ranchos by El Camino Real, Spain's old royal highway; and the land was adjacent to the Peralta grant.

11

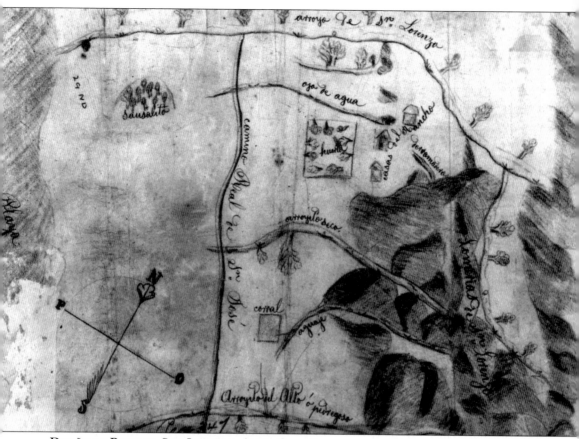

DISEÑO OF RANCHO SAN LORENZO ALTA. Castro's grant was approximately 27,000 acres, and this *diseño*, an informally drawn map that defined the boundaries of Mexican land grants, implied title. Rancho San Lorenzo was bordered on the west by what are now the Union Pacific railroad tracks, on the south by the modern axis of Harder Road, and on the north and east by the hills that enclose Castro Valley. San Lorenzo Creek can be seen at the edge of the drawing, the El Camino Real runs across the map's center, and Castro Valley would be to the left of the area pictured. After American conquest, Congress passed the Land Act of 1851 to confirm the title of Mexican grants, though many Californios were forced to sell much of their rightful property in order to pay attorney fees as their claims moved through American courts. Castro was further crippled by a disastrous trip to southern California, when he lost $35,000 in a night of gambling. Burdened by debt, Castro gradually sold off his estate, leaving for South America in 1864.

THE CASTRO ADOBE. Castro Valley's grasslands lay near the northern terminus of Rancho San Lorenzo, and were primarily utilized for cattle grazing. The real center of rancho life was the Castro family adobe and its adjoining plaza, corrals, and rodeo grounds that were built on the knoll where Hayward's old city hall now stands. Every year the *mantanzas*, or slaughters, were held there after cattle were gathered from Castro Valley's pastures.

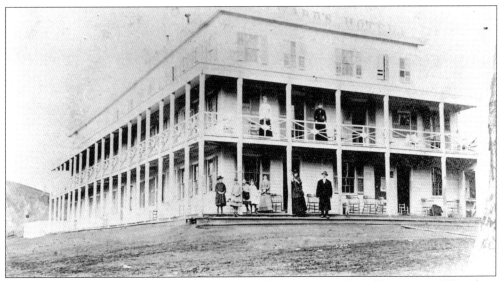

HAYWARD'S HOTEL, 1876. Development of this 100-room hotel began in 1851 when William Hayward purchased a piece of land from Guillermo Castro on the corner of today's A and Main Streets in Hayward. Benefited by its proximity to mountain passes and Hayward's position as county road commissioner, the hotel was an essential stopover for anyone traveling between Oakland and San Jose or Livermore via Castro Valley and Dublin Canyon.

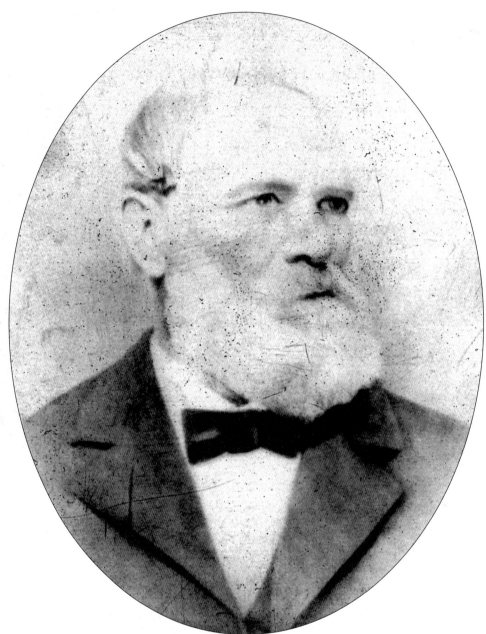

WILLIAM HAYWARD. Although Castro Valley officially became part of the United States after the signing of the Treaty of Guadalupe Hidalgo, which formally ended the U.S.-Mexican War in 1849, it was the California gold rush that forever altered the history of the region. William Hayward, a failed gold seeker, arrived in Palomares Canyon as a squatter in 1851. After convincing Castro to let him remain, he established a hotel and made a fortune catering to travelers between San Francisco and the gold fields. His actions to promote the town of Hayward facilitated the development of surrounding territories' resources and agriculture, though for many years Castro Valley was simply referred to as the rural territory "north of Hayward's." Eventually, the valley came to be known for its game farms and lumber mills along Redwood Road, which in turn facilitated the growth of the city of Hayward.

**FAXON D. ATHERTON,
1815–1877.** An investment
of $400,000 bought Faxon
Atherton 27,000 acres of the
Castro Rancho at a sheriff's
sale in 1864. Atherton turned
over $120,000 in cash to
Castro himself, and assumed
$280,784 worth of overdue
mortgage notes. He then
appointed his friends Alex
Grogan and J. H. Ward
to serve as land agents,
parceling out Castro's rancho
in small allotments to early
American settlers.

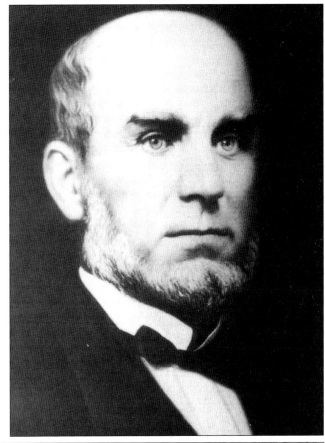

**BOARDMAN MAP OF CASTRO
VALLEY AREA.** This map
drawn by William Boardman,
the official surveyor of
Alameda County during the
1880s, shows the territory of
the unincorporated area of
Castro Valley. Even then, the
distinct arch of the main road
through the valley, known
as Mattox Road (now the
Boulevard), is clearly visible.

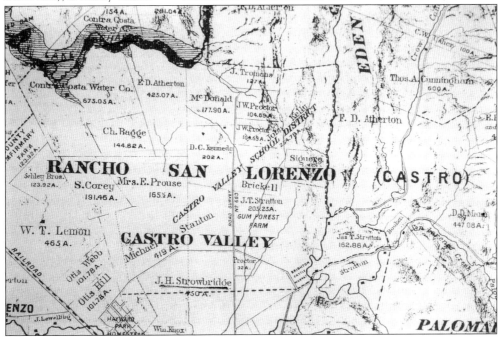

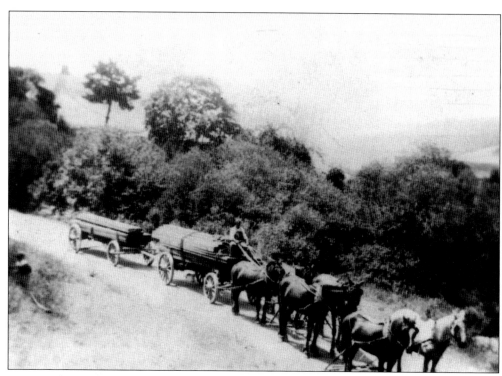

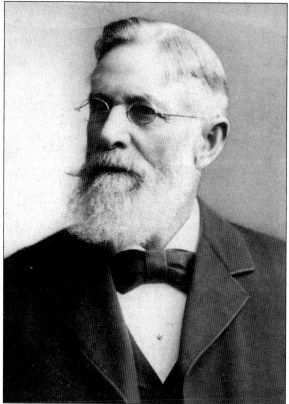

OLD REDWOOD ROAD. Redwood Road was originally used to transport lumber from the forests around the East Bay Hills, south through Castro Valley, and on to Robert's Landing. Planked in areas prone to flooding, the road's traffic typically consisted of ox- or horse-drawn logging trucks such as this one. Much of the region's redwood was used to build San Francisco's early structures, particularly after its devastating series of fires.

JAMES HARVEY STROBRIDGE. Strobridge came to California during the gold rush and was later employed by the Central Pacific Railroad as superintendent of construction for the western portion of the transcontinental railroad. Strobridge had a reputation among his workmen as a harsh disciplinarian, and oversaw the largely Chinese workforce that breached the Sierras. In 1869, he purchased 500 acres in Castro Valley and built a house on the property.

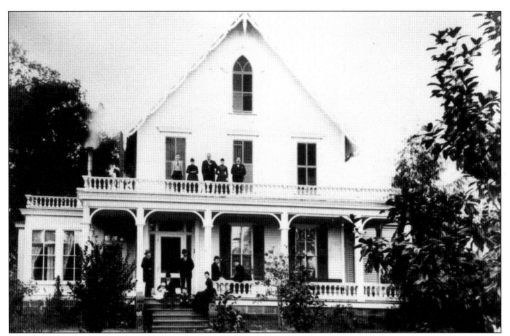

THE STROBRIDGE HOUSE. Even after Strobridge settled in the valley, he continued working for the Central Pacific, supervising the construction of track between Niles and Oakland as well as links between other points. It is not difficult to imagine that some of the heads of the Central Pacific are pictured here, enjoying a respite from their busy schedules, with J. H.'s family at his home in Castro Valley.

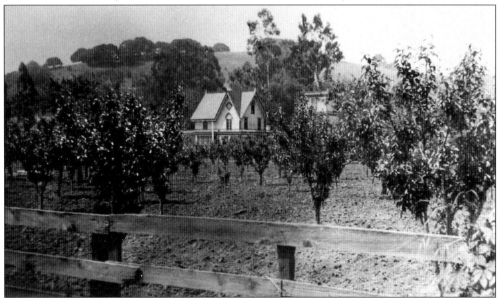

STROBRIDGE ORCHARDS. Around his new home, Strobridge planted apricot and pear orchards and raised cattle. Here Strobridge adopted and reared five children with his first wife, Maria Keating Strobridge, who was a steadfast partner, even during his term working for the railroad in the Sierras. After her death in 1891, Strobridge would remarry twice, first to Kate Moore, who died in 1895, and finally to Margaret McLean in 1896.

MICHAEL STANTON. Michael Stanton, an early pioneer of Castro Valley, worked with his neighbor James Harvey Strobridge for the Central Pacific Railroad as a manager of railroad construction crews, and the two formed a business partnership after completion of the transcontinental railroad. In 1872, Stanton purchased 419 acres of William Mattox's former ranch along the San Lorenzo-Dublin County Road and built a home near the present site of Eden Hospital.

MARY STANTON. Mary Stanton settled with her husband, Michael, in Castro Valley in 1872, rearing John T. and Anita in their home that still stands in the valley today. The family's legacy can be seen all over Castro Valley, as a number of streets are named for the Stantons: Miguel and Santa Maria Avenues were named for Michael and Mary, and Anita for their daughter.

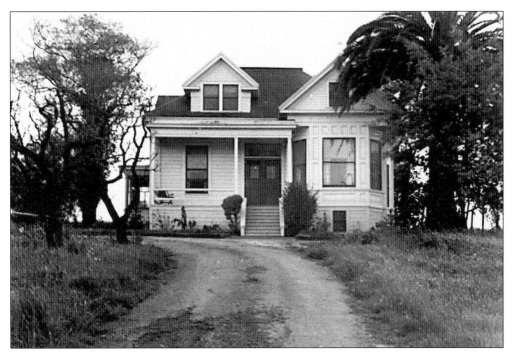

PETER HOARE'S HOUSE. Peter Hoare was road master of the Castro Valley Road District during the 1880s and 1890s. He met his wife, Hannah Brickell, daughter of Josiah Brickell, during this time and they built this home together on her family's land in the 1890s. Hoare was the chief planner of the railroad bed between Pleasanton and Niles, as well as hundreds of miles more of roadway around the East Bay.

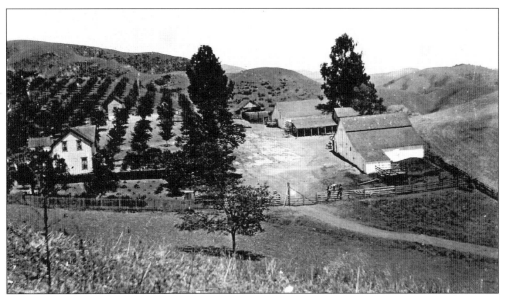

JENSEN HOUSE. The Jensen Family has resided in the region since 1867, when Erich and Jens Jensen purchased 450 acres of grazing land in the hills east of the valley at $7 an acre from developer Faxon D. Atherton. Natives of Denmark, the family home along what was Jensen Road became a meeting place for Danes who would make their homes in the valley and the town of Hayward.

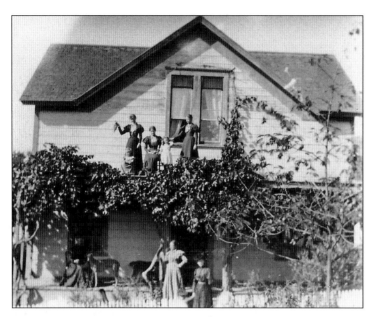

JENSEN HOUSE AND RESIDENTS. Seen here at a delightfully candid moment, the Jensen family poses around and above their 19th-century "salt box house," which still stands today in the middle of the Palomares Hills housing development. The Jensens had orchards and wheat fields, and also raised cattle, pigs, and poultry, making the homestead in far eastern Castro Valley completely self-sufficient.

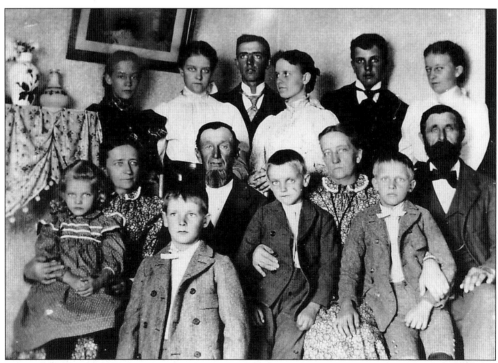

JENSEN FAMILY PORTRAIT. Pictured here are Erich and Jens Jensen with their wives, Emilie and Christiane, and Jens and Emilie's 10 children. The children would come to think of both couples as parents while growing up together on the brothers' ranch in East Castro Valley. Although the ranch was sold in 1977, the original homestead still sits in the middle of the Palomares Hills housing development, inhabited by the Jensens' descendents.

VAN HOOSEAR HOUSE. Another early family in the Valley was the Van Hoosears, who built their home on Seven Hills Road in the late 19th century. Young Fanny Mancini and Fredrick Brons stand in front of the house in 1915. The house is one of only a few belonging to Castro Valley's early settlers that still stands today.

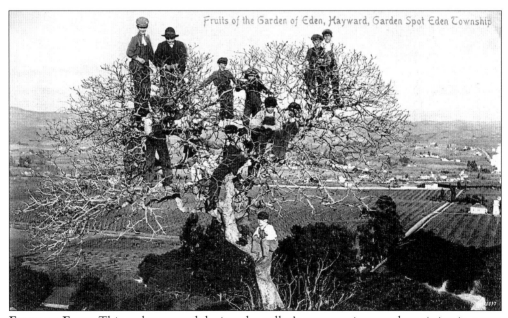

FRUIT OF EDEN. This early postcard depicts the valley's most precious produce sitting in a tree on the Strobridge family's Laurel Ranch on the valley's southwestern side. The cross street on the right is probably the intersection of Redwood Road and Grove Way, the site of Thomford's Exchange, Castro Valley's first business.

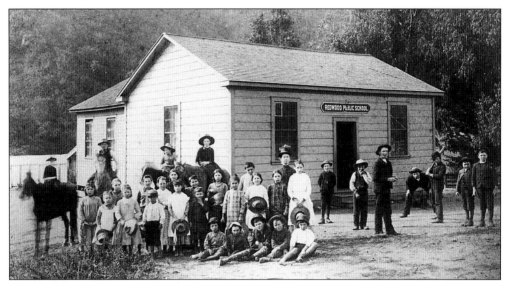

CASTRO VALLEY'S "FIRST" SCHOOL, AROUND 1894. Josiah Grover Brickell donated a portion of his property on Redwood Road for Castro Valley's first permanent school facility, known as Redwood School, in 1866. Although a plaque erected on the site in 1962 commemorates the site of Castro Valley's first school, the actual title belongs to Zacharia Hughes's tiny structure, purloined by the city of Hayward in 1864.

EDEN VALE SCHOOL. Methodist minister Zacharia Hughes built the area's first school in 1853, called Eden Vale, but it was moved to the town of Hayward in 1864, where most of the school's student's resided. This picture shows the school's original location in Crow Canyon, north of Norris Canyon.

My father bought an acre & ⅓ from Geo. Jorgensen in 1935. He had a house built in May 1935 on 18308 Carlton Ave near Lake Chabot Road. We could walk to Carlton Ave and go down the street to see Lake Chabot. Mrs. Silverson had a home that one could see Lake Chabot near L.C. Road!

Two

THE PIONEERS
1880–1940

Off Carlton Ave.! - 18308 1935 - Jennes. Edwards built the house. He had the home built by a builder that year. Neighbors were the Haynes, Hahn, Fatini, Gordon, Peterson, and many others.

A half-century of American occupation left little mark on Castro Valley. Office buildings, paved streets, trolley lines, and other trappings of urbanization appeared in adjacent communities, yet the valley remained largely unchanged since the days of the Rancho San Lorenzo—a quiet ranching and agricultural region.

The early decades of the 20th century, however, ushered in a new era of modernization. The shelter provided by the surrounding hills was perfect for raising chickens, and Castro Valley was, by the end of the 1920s, a leading center of the poultry industry. The Rio Linda Hatchery, the Freeman Pullet Farm, and Perry's Peerless Peeps were among the state's largest hatcheries, transporting their chirping hens hundreds of miles and joining with dozens of small-scale poultry ranchers to drive the valley's population of layers and fryers to almost a million.

But all was not fowl in Castro Valley. This era ushered in the first commercial establishment on the Boulevard, the arrival of a fiery radio evangelist who kept bees on the side, as well as (much to the evangelist's chagrin) the appearance of numerous speakeasies and back-lot stills. The relatively isolated valley provided safe haven for those taking a friendly pull at the bottle until the end of Prohibition, and later Castro Valley's first wineries would satisfy Depression-era residents' need for a good drink.

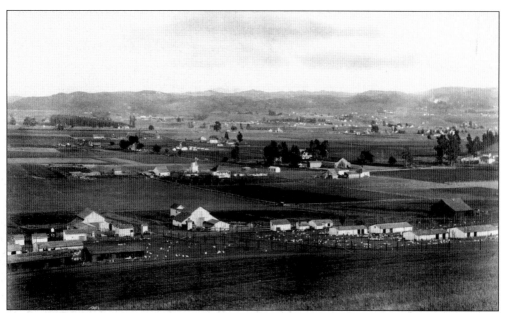

CASTRO VALLEY, AROUND 1900. Castro Valley's yet undeveloped state is apparent in this turn-of-the-century photograph, which looks east across the valley and its sprawling ranches. The small white dots in the foreground are chickens, milling about their holding pens. Castro Valley's fowl would continue to outnumber the region's human inhabitants until the early 1950s.

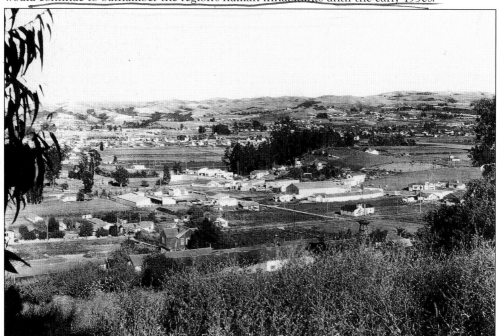

CASTRO VALLEY, AROUND 1930. Castro Valley changed little between 1900 and the late 1930s, when this photograph was taken. Stanton Avenue is in the foreground, with eucalyptus trees in the center, standing on the hill above the southern terminus of Lake Chabot Road. All of old town's early businesses are visible along the Boulevard, including Orin Crowe's Feed Store in the long white barn, now Brian Morrison's Heating and Air. ❋

My family bought land in 1935
❋ *I knew him.*

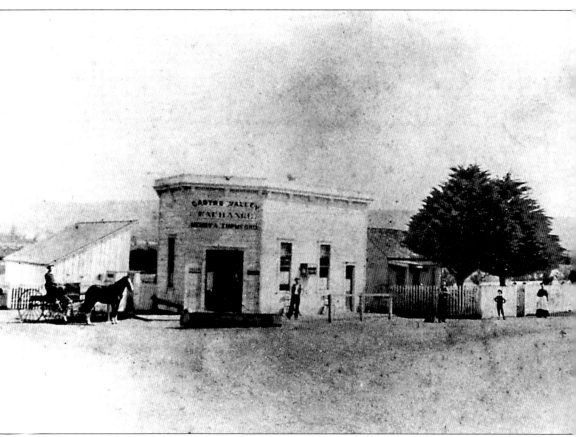

CASTRO VALLEY EXCHANGE. In 1881, Henry Thomford opened what was probably the first commercial business in Castro Valley on the corner of Grove Way and Redwood Road, at the present-day location of Trader Joe's market. A natural transportation nexus, the exchange was a popular stopover both because of its prime location and its appealing wares. The tiny exchange was actually a saloon, serving travelers and teamsters driving cattle along the dusty Dublin Road, offering troughs of water for the livestock and cool pints of beer for the weary sojourners. Thomford, the great-grandfather of coauthor Lucille Lorge, also served cheese, pickles, and sausages freshly prepared by his wife, and would sometimes even allow the brave-of-heart to sneak a peek at his three-headed chicken, preserved in a jar of alcohol.

CHICKENS REIGN SUPREME. Poultry had been the center of Castro Valley life since 1906, when Arthur Bailey and A. J. Geandrat established the area's first mass-production poultry farm. Many others followed, even forming a local cooperative called the Hayward Poultry Producers Association. Only the postwar population boom would end poultry's reign over the area, when subdividing and selling chicken ranches became more profitable than operating them.

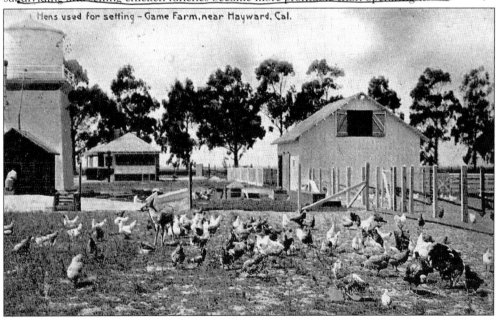

Hens used for setting – Game Farm, near Hayward, Cal.

GAME FARM POSTCARD. Chickens, turkeys, and a lone deer make this valley game farm home. At its height, Castro Valley had 12 hatcheries and hundreds of chicken farms, most yielding less exotic stock than this. Though the farm was within Castro Valley's borders, the postcard caption reads "near Hayward," illustrating that the valley's unincorporated status initially forced it to derive location and status from the closest incorporated community.

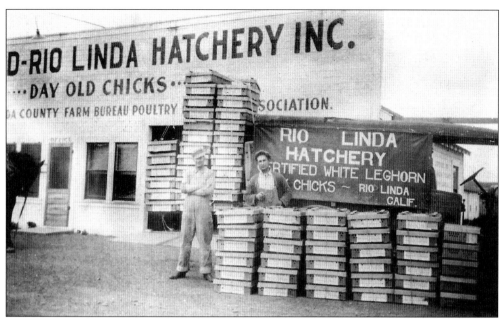

HAYWARD RIO LINDA HATCHERY, 1926. Two Hayward Rio Linda Hatchery workers pose with a collection of live chicks, ready for shipping. Chicks were usually crated 100 to a box and delivered locally by truck. However, Castro Valley ranchers could ship their chicks any place in the world, provided the journey was completed within 48 hours, as the egg yoke provided hatching chicks with sustenance for approximately two days.

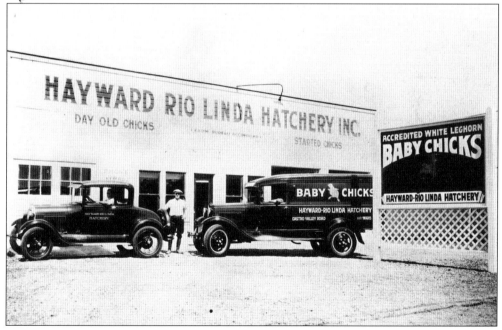

HAYWARD RIO LINDA HATCHERY VEHICLES, AROUND 1926. Although a longtime Castro Valley concern, the hatchery carried Hayward as part of its moniker because Castro Valley had no post office until the 1930s. The business hatched roughly 30,000 chicks a week. Workers turned eggs by hand every eight hours to provide even warmth and moisture for the embryos.

CASTRO VALLEY CHICKEN RANCHERS, AROUND 1927. Castro Valley hatchery owner Cyril Lorge is at the wheel and fellow rancher Mike Kramer appears ready to turn the crank on their Model T truck, filled to capacity with a load of 4,200 chicks. By the late 1920s, the Chanticleer Electric Hatchery, Freeman Pullet Farm, Perry's Peerless Peeps, Rio Linda Hatchery, and numerous other hatcheries called Castro Valley home.

PREACHER PHILLIPS. A Baptist minister with a reputation for delivering fiery sermons, as well as a world-renowned beekeeper, George W. Phillips moved from Oakland to Castro Valley with his family in 1922. They bought 25 acres of land in the western hills of the valley behind Stanton Avenue where he kept bees to supplement his income, so long as it did not interfere with his functions as a minister.

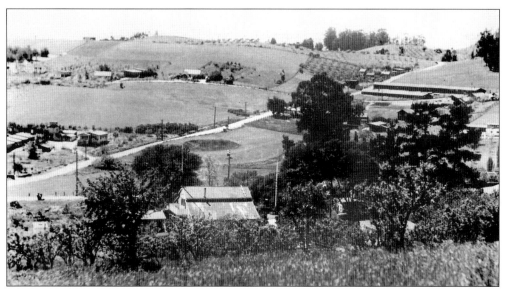

PHILLIPS RANCH. In addition to bees, Phillips kept an orchard of relatively exotic trees and vines on his ranch, growing everything from persimmons, apples, apricots, almonds, and prunes to grapes and even the area's first pomegranate trees. But ministering would always come first, and it is said he would practice his sermons by going into the eucalyptus grove behind his home and letting them boom out into the trees.

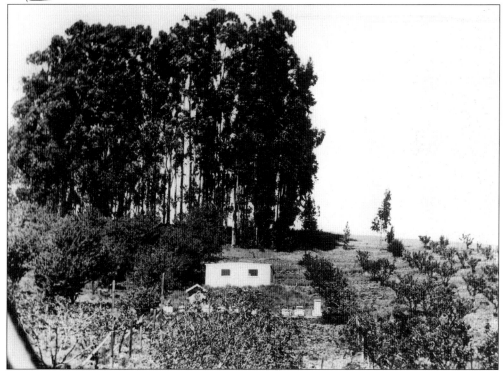

PHILLIPS BEE HOUSES. The small white boxes below the main structure appear to be Phillips's beehives, where he first developed his world-famous strain of queen bees. Phillips's reputation for the queens became so great that he began shipping them to beekeepers all over the world.

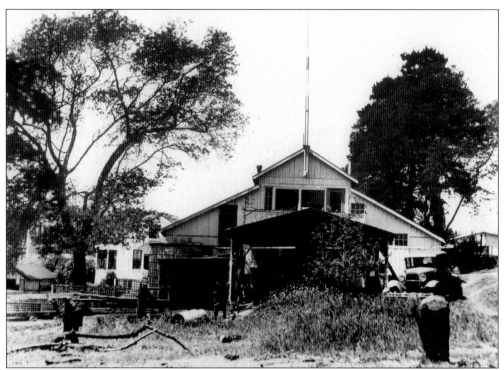

THE PHILLIPS RADIO AERIAL. A pioneer in the use of radio transmission to spread his message, Phillips began to broadcast his "Daily Hour of Prayer" in 1925 from the loft of his Castro Valley barn. The antennae can be seen prominently mounted on the exterior and was the lightning rod through which this passionate preacher rendered his message.

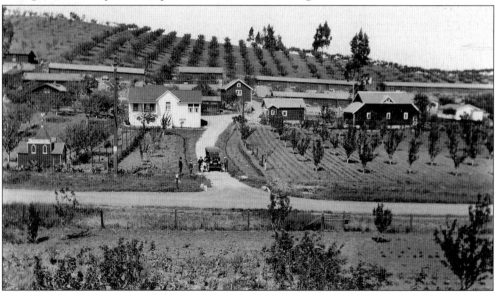

LUNDGREN RANCH HOUSE, AROUND 1920. Typical of the picturesque Castro Valley homes of the interwar years is this home on Stanton Avenue, complete with orchards, brooder houses, and barns. The Lundgrens gather around the family vehicle, which appears to be a brand new Model T, on their dirt driveway on Stanton Avenue, between Sommerset and Sydney Way.

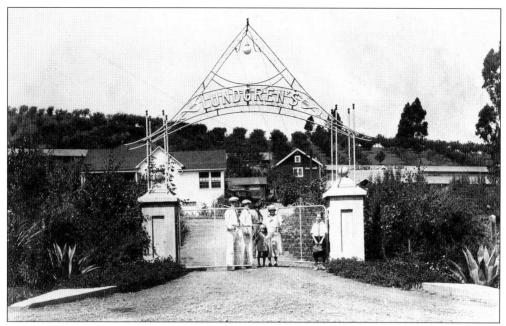

THE LUNDGREN FAMILY, AROUND 1920. The Lundgrens immigrated to California from Sweden and, like so many valley residents of the period, made their way to the area to raise poultry and farm. Here the whole household poses at the gate of their ranch house on Stanton Avenue as the ancestral name proudly arches above the entrance, declaring the arrival of this early family.

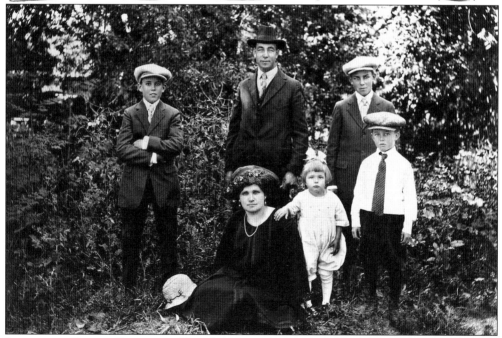

LUNDGREN FAMILY PORTRAIT. Here father, mother, and children Oscar, George, Art, and Esther Lundgren pose for the camera. All of the children would attend Castro Valley Grammar School, and all of the boys would go on to join the Navy, each achieving the rank of commander or higher.

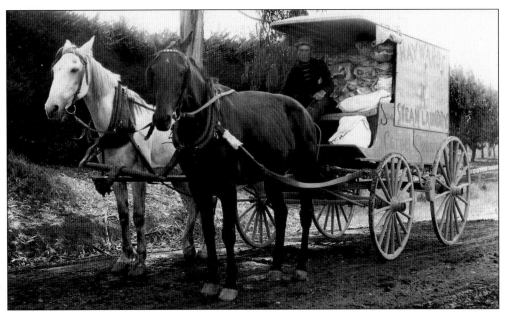

HAYWARDS STEAM LAUNDRY. Throughout the late 19th and early 20th century, Hayward businesses like the Haywards Steam Laundry made regular runs to the ranch houses in Castro Valley. Though only a short journey between the two regions by car, the trek by horse and buggy was often a demanding one, and the continuation of such commerce demonstrates the vital link between the valley and the commercial centers to the south.

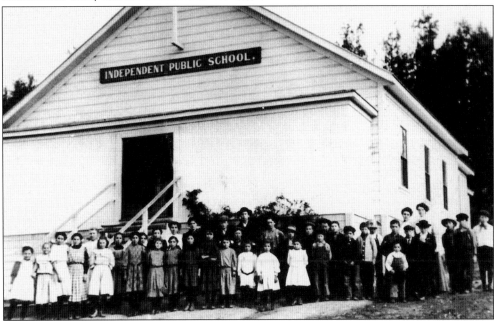

INDEPENDENT SCHOOL BUILDING, AROUND 1900. The Independent School District was established in 1892 after years of dissatisfaction with the inclusion of Castro Valley into a number of successive, splintered districts. Rancher Arthur Manter donated a 1.75-acre tract of land along Crow Canyon Road for the Independent School site, and other canyon ranchers contributed lumber to construct the two-room schoolhouse, a horse barn, and an outhouse.

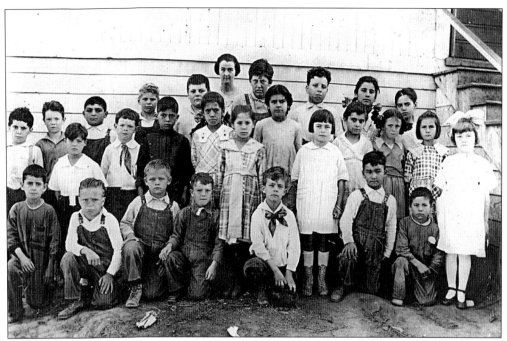

THE INDEPENDENT SCHOOL. Independent School children pose for the camera in this 1921 group photo. At this time, the population in East Castro Valley was largely Portuguese, but also included families of German and Danish descent. Independent School consequently boasted a diverse student body, and families such as the Holgrafes, Flores, Azevedos, and Manters all sent their children to be educated there.

THE BOULEVARD. A group of children play on the Boulevard and are in no danger of encountering the busy cross-traffic that pervades it today. Dating back to the 1850s, the Boulevard was known by government officials as County Road No. 248, and by locals as Mattox Road. It was an important link between Central Valley and San Francisco Bay commerce.

PINECONES ON THE BOULEVARD. Perhaps in the spirit of Castro Valley's pioneering businessmen, children launch a bold pinecone sales venture on the Boulevard. In addition to the more typical games of American kids, Castro Valley children made it a tradition to wait for the Alameda County water wagon to pass by, showering in the spray of the vehicle as it attempted to water down the dusty valley's unpaved roads.

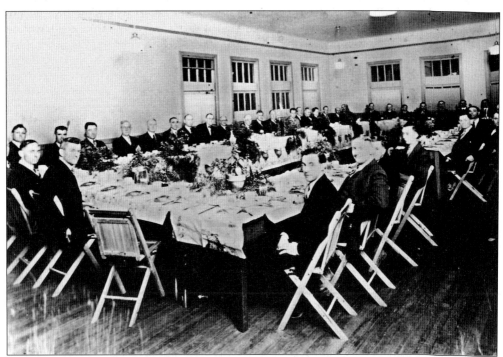

CLUB MEETING AT A LOCAL RESTAURANT, AROUND 1930. Here, a local social club meets at an unidentified Castro Valley restaurant during the 1930s. As more businesses came to the valley, local entrepreneurs were eager to form both commercial and social ties with each other and develop a more settled community. A mark of the burgeoning economy and society, trade associations and membership clubs began appearing as early as the 1920s.

34

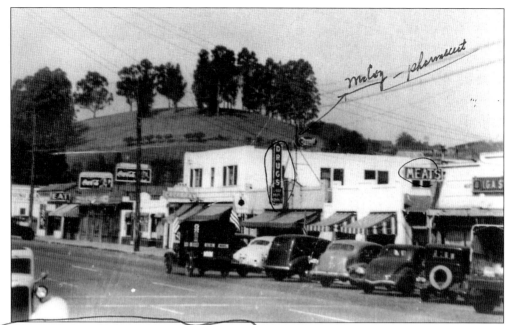

maloz — pharmacist

CASTRO VALLEY BOULEVARD, AROUND 1935. This photo, looking west to the hills where Neighborhood Church now stands, shows downtown Castro Valley between Stanton and Lake Chabot Roads on the Boulevard. A two-lane concrete road, the Boulevard was the most modern thoroughfare in the region. Redwood and Lake Chabot Roads had only a basic coating of tar that oozed in hot weather and was used as "chewing gum" by local children.

* *We moved to C.V. in May 1935! I knew this photo very well!*

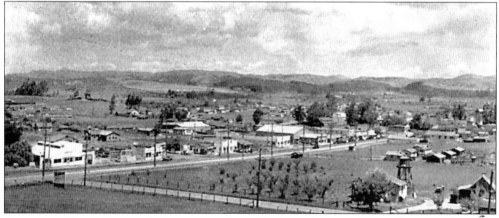

RARE OLD TOWN PHOTO. This rare overview of "old town" Castro Valley illustrates the as-yet limited development of the business district in the 1930s, where ranches and orchards seem to outnumber storefronts. The ranch in the foreground is said to have been the birthplace of the very first "Lassie" collie dog, used in the filming of the beloved family movie.

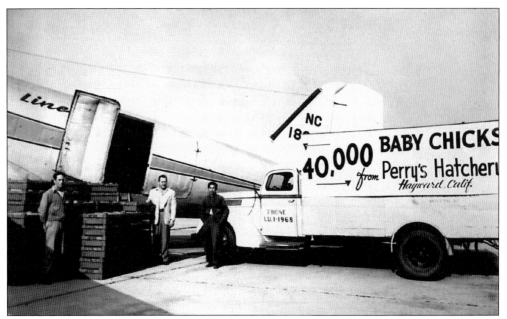

VALLEY POULTRY AROUND THE WORLD. Perry's Peerless Peeps, located on Stanton Avenue, was one of a handful of Castro Valley hatcheries that began to ship chicks around the world in the 1930s. Owner John Perry's whole family was in the poultry business, and his brother Ed was co-owner of the Hayward Rio Linda Hatchery. Here, Perry's truck delivers a full load of 40,000 live chicks to a waiting aircraft.

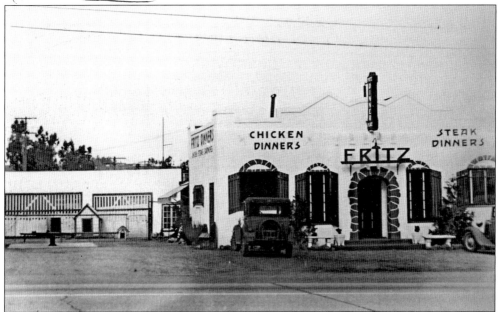

FRITZ'S CHICKEN DINNERS, AROUND 1940. Originally the site of the valley's first barbershop, and owned by a businessman known as Happy Jack, Fritz's Restaurant became a popular local eatery. Beyond operating the restaurant, Mrs. Fritz raised St. Bernards and cared for foster children, the latter assisting with such restaurant duties as dishwashing. The dogs' restaurant duties were said to consist of biting the heads off the chickens served at the diner.

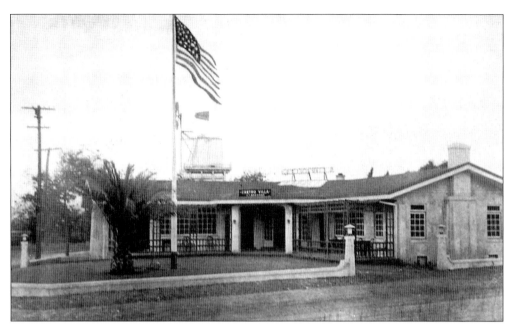

CASTRO VILLA. The Castro Villa was constructed in the early 1900s on the former site of Thomford's Exchange at the corner of Grove Way and Redwood Road, a hub of activity between Hayward and the valley. The first owner, Gus Volker, served chicken and duck dinners to tourists journeying to nearby resorts in Hayward, and in 1935 it was bought by the Salvadorini family, who kept the business prospering.

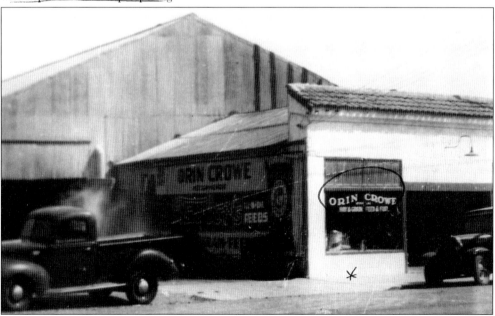

ORIN CROWE FEED STORE, AROUND 1924. The first business on Castro Valley Boulevard, Orin Crowe's Feed Store, opened its doors in 1924, selling feed and coal to local ranchers. Soon his business was prospering and Crowe was able to build two houses on Lot Road, now San Carlos Avenue: one for himself and wife Vivian, and the other for his in-laws, the Parmalee family. Both homes still stand today.

* I used to go here with my father to get chicken feed and hay from (1935-1943)

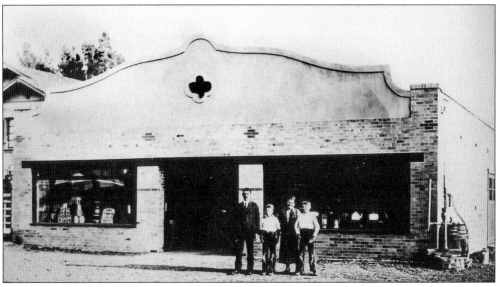

✱ **PETE'S HARDWARE, AROUND 1926.** In 1926, Pete Selmeczki opened Pete's Hardware across from Orin Crowe's feed store, becoming the second business to appear on Mattox Road, as the Boulevard was commonly known. Although a few changes have been made over the years, the store remains in its original location and the Selmeczki family still owns the business. Pictured, from left to right, are Pete, Ernie, Mary, and Frank Selmeczki.

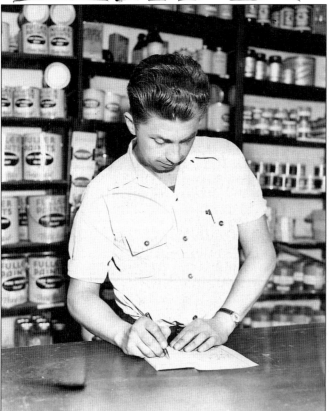

ERNIE SELMECZKI. Pete Selmeczki emigrated from Hungary in the early 1920s. A painter by trade, he took a risk in starting his hardware business in the undeveloped commercial center of Castro Valley, but ultimately created one of the valley's most enduring legacies. His son Ernie, pictured here, kept the business prospering through the 20th and into the 21st century, and he still lives in the valley today.

38

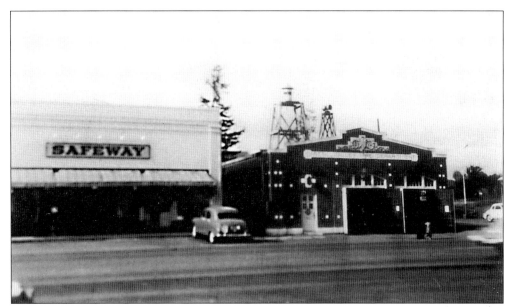

SAFEWAY RARE SHOT. This rare image of Safeway is believed to be the only photograph of the store's first Castro Valley Safeway built store, on the corner of Lake Chabot Road and the Boulevard. The grocery store remained in this small structure until a newer, specially designed facility could be constructed closer to the center of town, on the corner of Castro Valley Boulevard and Redwood Road, where it is still located. *I used to go there.*

AL NUNES'S CAFÉ. Al Nunes was another of the Boulevard's pioneer businessmen whose family owned a large portion of land along that thoroughfare at the southern terminus of Lake Chabot Road. In addition to parceling out the land and its various structures to many other local businessmen throughout the years, the Nunes family also established this café on the acreage where Carrows restaurant stands today.

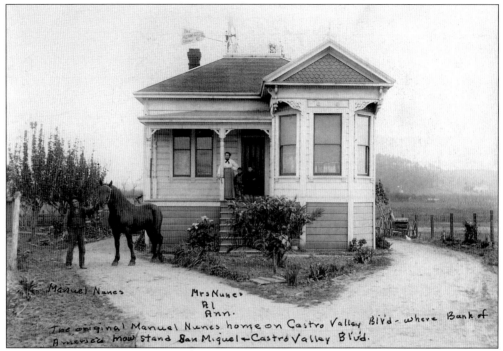

Manuel Nunes Mrs Nunes
 Al
 Ann.

The original Manuel Nunes home on Castro Valley Blvd - where Bank of America now stand San Miguel + Castro Valley Blvd.

NUNES FAMILY HOME. This understated Queen Anne cottage was the original Nunes family home that was built by Manuel Nunes, who is pictured with his horse, while his wife, Ann, stands in the doorway with the two children. The home was built on the family's large ranch on the south side of the Boulevard, at the present-day location of the Bank of America.

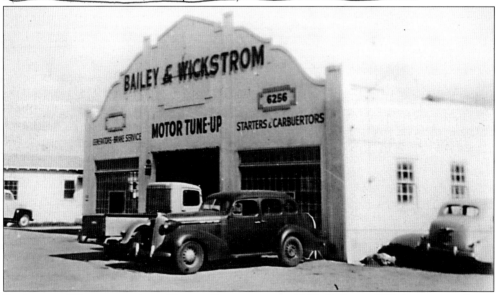

BAILEY AND WICKSTROM AUTO REPAIR SHOP, AROUND 1940. Bailey and Wickstrom stood next to Nunes's Café and served Castro Valley automobile owners throughout the 1940s and 1950s. Eventually, the Quonset hut garage closed, and the building was transformed into a popular antique shop before finally being leveled in the 1970s. The site is now part of the Carrows Restaurant facility, at the intersection of Lake Chabot Road and the Boulevard.

40

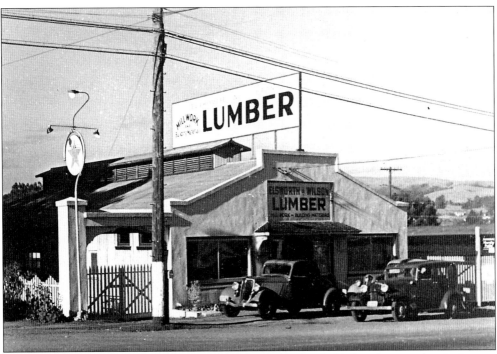

CASTRO VALLEY LUMBER COMPANY. Castro Valley has a remarkably long history of stores, homes, and even schools being physically relocated—lathe, plaster, timber, and all—in the valley. Two early businessmen, Clarence Elsworth and Robert Wilson, did just that by moving their lumber store from the north side of the Boulevard, on the corner of Stanton, to the south side, where Castro Valley Lumber still stands today.

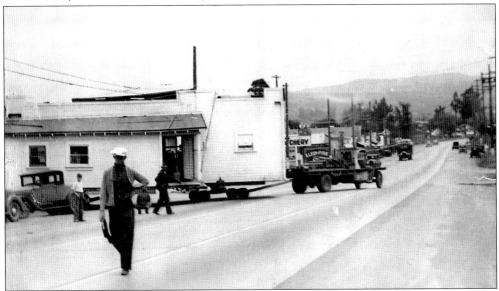

CASTRO VALLEY LUMBER MOVES. Here is actual documentation of one of the early storefront relocations in the valley, as workmen move the Castro Valley Lumber building across the Boulevard, about 50 feet from its original location. The temporarily mobile business appears better suited to life on solid ground, and seems dangerously close to clipping the Model A Ford in the foreground.

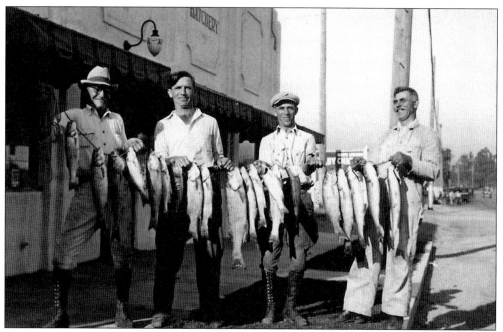

FISHING DAY IN THE DELTA. It's nice to know that the hard-working men who pioneered the business and trade along Castro Valley Boulevard were able to find time for a fishing trip in the region. Pictured, from right to left, are Pete Selmeczki, owner of Pete's Hardware, Cyril Lorge, family friend, and Ed Perry. Lorge and Perry were owners of the California State Hatchery, pictured behind them.

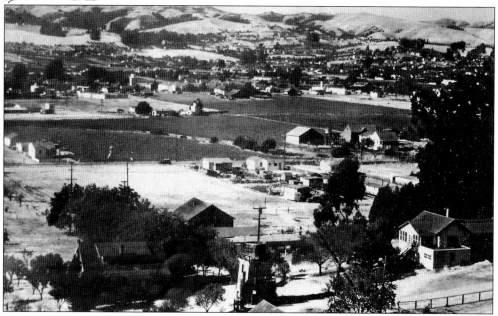

VALLEY TOMATO FIELDS, AROUND 1940. Looking southeastward across the valley around 1940, Castro Valley continues to exhibit mostly rural characteristics with widely separated residences, dirt roads, and a large tomato field at center. In the distance, the Boulevard can be made out. The tall, white tower of the L&W Drive is at far right.

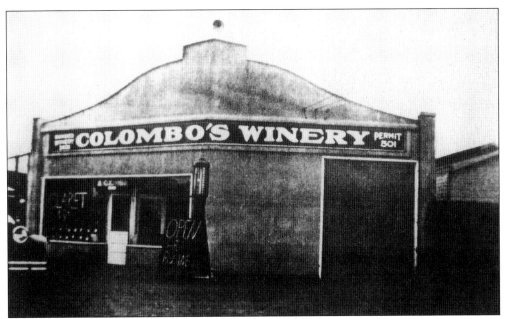

COLOMBO'S WINERY. As the Depression began and the government officially ended Prohibition, businesses like Colombo's Winery and other liquor stores began to appear in the valley, replacing the speakeasies and illicit stills of the 1920s. Castro Valley became a renowned producer of moonshine and "bathtub gins" prolific during the dry decade, furnishing the nearby resort town of Hayward with the much-needed supply.

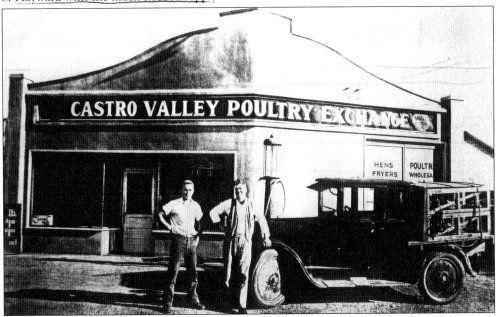

CASTRO VALLEY POULTRY EXCHANGE, AROUND 1933. Although many of the valley's legitimate liquor suppliers enjoyed success for decades after the Depression ended, others once again adapted to changing trends and tastes in the valley by switching from alcohol to chickens. Pictured here, after transforming their winery into a poultry exchange, are Anthony Colombo and George Popra, who intended to put a chicken in every Castro Valleyian's pot.

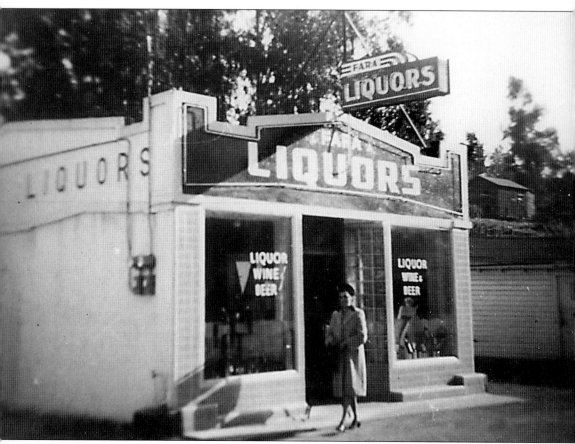

FARA LIQUORS, AROUND 1940. In the mid-1930s, Fara Liquors opened a small storefront where Lake Chabot Road meets the Boulevard. During Prohibition, the structure had been a gas station where owner Charlie Gall sold alcohol labeled "The Pride of C.V." to satisfy the thirsts of valley farmers. He also sold gasoline. When locals began to notice a petroleum substance in the creek near his station, a mysterious Mr. Baker started building a 50-foot oil derrick and selling shares in his stake of what would surely become the richest oil strike west of Texas. Residents of the valley were convinced they would all soon be rich, but when a leak in one of Charlie's buried gas tanks was found to be the cause of the petroleum substance, the dream was over and Mr. Baker had disappeared with everyone's money. Baker Street, which runs off the Boulevard, still bears the one-time prophet's name, and Fara's soon opened to take advantage of the whole valley's need for a stiff drink.

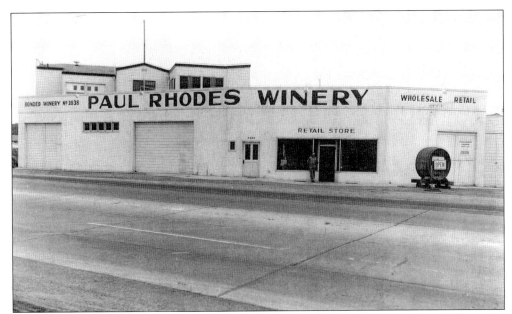

PAUL RHODES WINERY, AROUND 1937. The Paul Rhodes Winery opened in 1937 on the northwest side of Castro Valley Boulevard and was part of the later Depression-era liquor trend in the valley. The Rhodes family imported the grapes for the wine from vineyards in Livermore and Pleasanton, bottling it only after a three-year aging process in oak barrels. The winery closed in 1968, after a long and successful run.

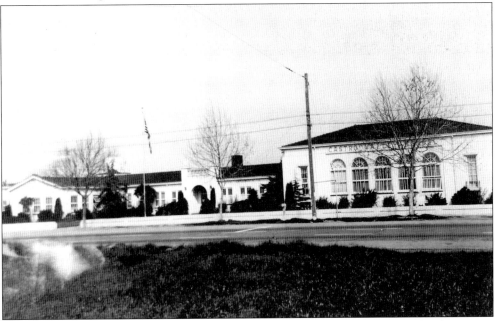

CASTRO VALLEY SCHOOL, 1922. Castro Valley Grammar School opened in 1922 after the passage of a $37,000 bond and a lengthy debate over the facility's location. After considering tracts on Redwood Road and Lake Chabot Road, the local school board decided on a site along Castro Valley Boulevard, largely because the roadway was already equipped with concrete sidewalks and could accommodate storage for bicycles and cars and an outdoor eating area.

I went there from 1935-1939

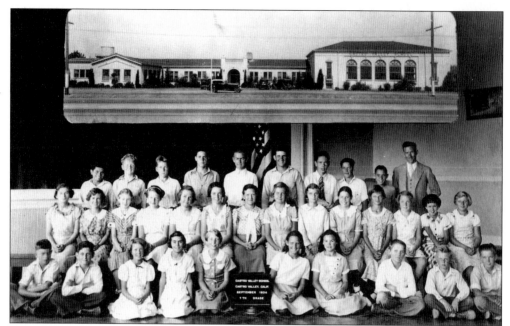

CASTRO VALLEY GRAMMAR SCHOOL GRADUATES, 1934. Here a group of Castro Valley Grammar School children pose for the camera in this Depression-era photograph, and many valley residents still remember having their photograph taken under the school mural. The school was condemned in 1954 and replaced by the Adobe Shopping Center. The main building stood where Blockbuster Video is now located.

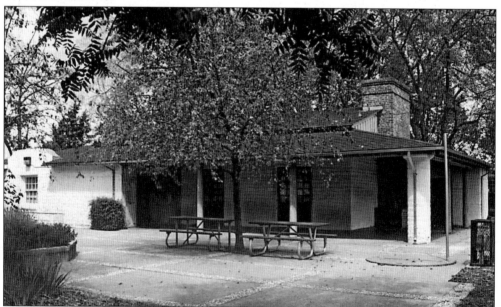

CASTRO VALLEY ADOBE. The Adobe was created by a Works Progress Administration (WPA) project in 1938, built with bricks made with dirt excavated from the site of the Redwood School and timber from discarded telephone poles. Placed in an elm grove planted by local Boy Scouts in 1926, residents used the adobe as a nursery, meeting room, and kindergarten from 1943 to 1959. It now serves as a community center.

46

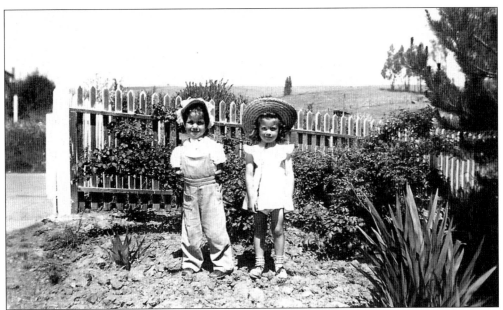

HANSON GIRLS. Little Arlene Stefani Hanson (left) and friend Antoinette play in the front yard of Arlene's grandpa's house on Heyer Avenue. Arlene's grandparents, the Stefanis, took the picture around 1946 just as the youth population in Castro Valley was beginning to boom.

MARCIEL HOME. Just up the valley from the Stefani's house, on the corner of Proctor and Redwood Roads, stood the Marciel family residence. Manuel and Isabelle Marciel bought the home in the early 1900s, and pictured here is Barbara Jean Marciel, their granddaughter, also enjoying some playtime at grandma and grandpa's house in 1943.

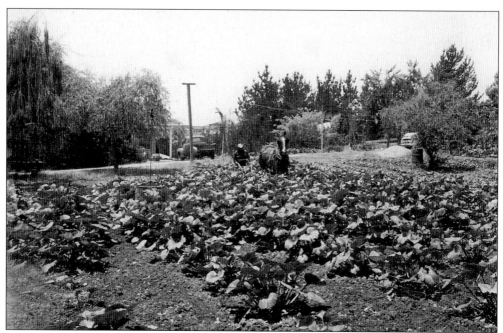

MANUEL MARCIEL. Manuel Marciel Jr., who lived on the original family homestead until Proctor School was built there, was the last vegetable farmer with his own roadside stand in Castro Valley, tilling the fields on his new property on the corner of Seven Hills and Lamson Roads from the 1950s to the 1980s. The property was later subdivided for housing. The Marciel Court development now stands in his old fields.

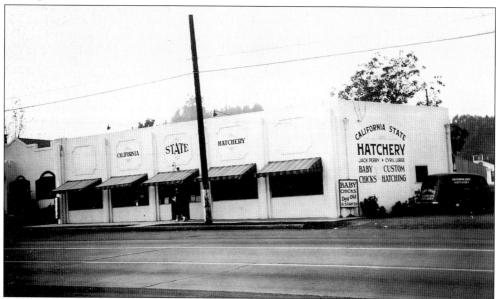

CALIFORNIA STATE HATCHERY. In 1934, Cyril Lorge and Ed Perry built the California State Hatchery, replacing the Hayward Rio Linda Hatchery (their former facility) with a more modern one. The structure now houses Connie's Tropical Fish and remains an integral part of the old town area today. The third generation of the Lorge family to live in Castro Valley still owns and operates R&J Quick Clean next door.

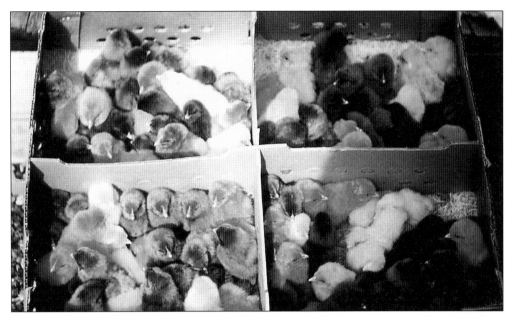

EASTER-COLORED BABY CHICKS, 1954. With Castro Valley's postwar transformation from agricultural center to residential suburb, housing developments replaced the old chicken ranches. In an attempt to stay in business, the owners of California State Hatchery used a vegetable dye to color and sell their cockerels that were usually disposed of. The chicks were sold to local families, complete with instructions on proper care.

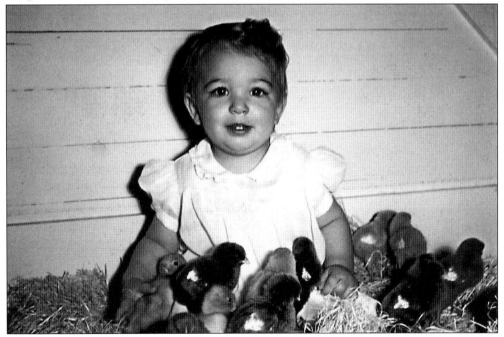

CHILD WITH BABY CHICKS, 1953. Sue Holm is pictured here with the colored baby chicks. California State Hatchery stopped selling the colored chicks after a few months, closed down its incubators, and eventually converted part of its facilities into a pet store. Connie's Tropical Fish now occupies the old site.

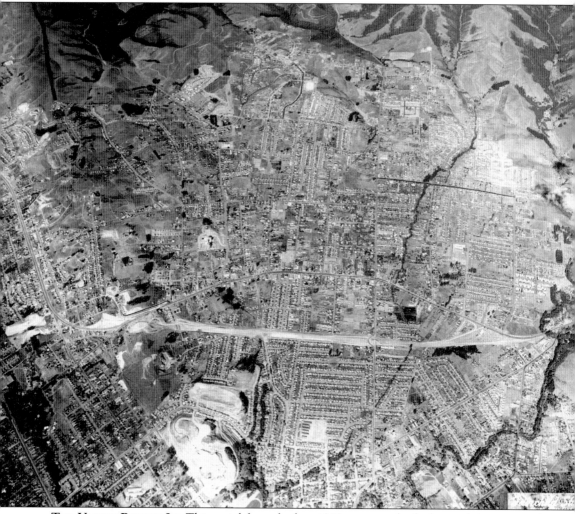

THE VALLEY RUSHES IN. This aerial from the late 1940s captures both the area's heritage and a glimpse of things to come as the valley stands poised and ready for suburban prosperity and growth. Thick eucalyptus groves, planted by farmers seeking a quick fortune in cheap lumber during the late 1800s, still stand, encircling some remnants of the first settler's homes, as if to shield them from the encroaching development. Rows of peach and almond orchards can still be seen on the edges of the valley, immediately adjacent to new housing tracts planted with equal symmetry and care. Even a few open fields lying fallow seem ready to receive the coming crop of young families looking to settle in "the heart of good living," as Castro Valley would be called. The whole expanse seems almost as if it were in motion, pausing only long enough to have this picture taken before resuming its rapid course of growth into a blossoming community, bearing the fruits of a new generation.

Three

THE CANYONS, THE RANCHES, AND A RODEO

Surrounding the wide expanses of Castro Valley are its associated canyons. Since the mid-19th century, the Crow, Cull, Dublin, Eden and Palomares Canyons, carved by the tributaries of San Lorenzo Creek, provided transportation routes for residents and conduits to get valley products to expanding markets to the east.

These canyons not only connect Castro Valley geographically, they also link Castro Valley to its past. The soil of the canyons prevented its widespread exploitation for intensive agriculture, as more fertile areas were readily available around Hayward, San Lorenzo, Ashland, Cherryland, and San Leandro. Ranching therefore survived in the canyons long after the conversion of former grazing land to residential neighborhoods on the valley floor and hillsides.

Part of that history is the Rowell Ranch, located in Dublin Canyon on the eastern boundary of Castro Valley, made famous by founder Harry Rowell. Now part of the Hayward Area Recreational District, the ranch has hosted an annual, weeklong rodeo competition for almost a century, drawing spectators from all over the world. In addition to watching bucking broncos, cattle ropers, clowns, and trick riders, residents continue to celebrate the Rowell Rodeo with an annual parade down Castro Valley Boulevard. This tradition, inaugurated by Guillermo Castro's Rancho San Lorenzo Alta, preserves the community's link to its ranching past.

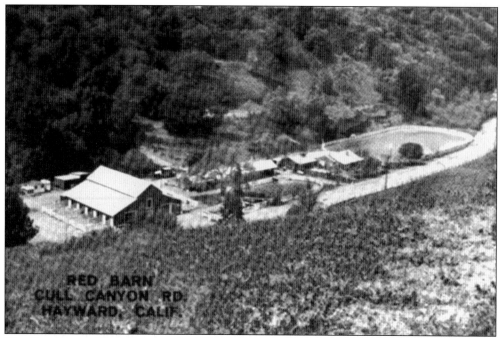

THE RED BARN, CULL CANYON. In 1855, William Cull and Daniel Luce purchased 2,400 acres of land in and around Cull Canyon at $7.50 an acre. The partners opened a sawmill, hoping for a return on their investment by reaping some of the rich redwood harvest found in the surrounding mountains. The Red Barn was part of William Cull's canyon ranch, where he remained until his death in 1896.

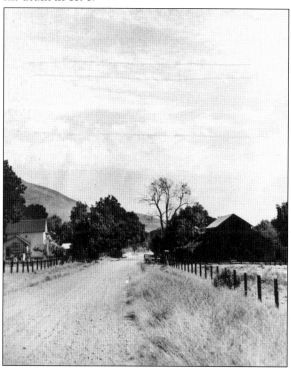

CULL CANYON ROAD, 1950s. Though Cull Canyon Road now dead-ends at the back of the canyon, it was once an important throughway for Cull and Luce's lumber transports traveling from the area, now known as Redwood Park, to as far as Robert's Landing. The Canyon itself was created by one of the tributaries of the San Lorenzo Watershed, and the region forms part of the valley's northeastern boundary.

CULL CANYON ROAD, 1970S. By 1960, Cull Canyon Road was almost fully paved, though some sections even today remain more dirt and gravel than asphalt. Valley residents now use the road to access two local parks, the Cull Canyon Reservoir and the Cull Canyon Regional Recreational Area, as well as the Columbia housing development atop the canyon's western ridge. The Red Barn, now showing its age, is visible to the right.

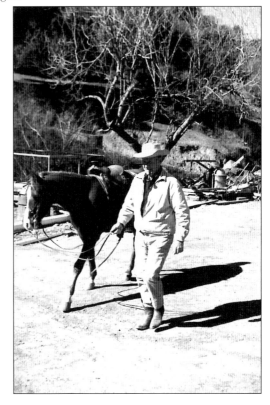

GUY WARREN. Local rancher Guy Warren, descendant of early pioneer Stafford Dean Warren, walks his horse on Geary Ranch in Cull Canyon. S. D. Warren arrived in the area in 1853 and established a commercial charcoal burner along Redwood Road. Leftover chips and bark from the lumber mills were recycled and baked in ovens to produce coal, which was in turn utilized in blacksmith forges from San Francisco to the Sierras.

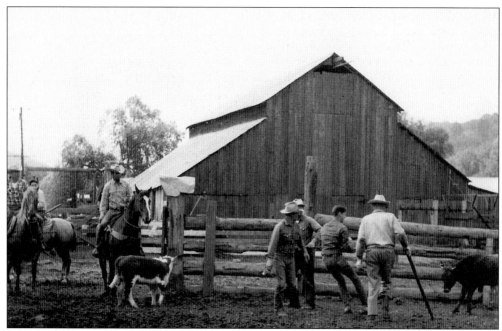

BRANDING LIVESTOCK, 1950s. Cull Canyon cowboys brand cattle with the Cull family's familiar red barn in the background, which is still utilized as part of a working ranch today. Guy Warren is at center, with his back to the camera. Some Warren descendants still live in the canyon today.

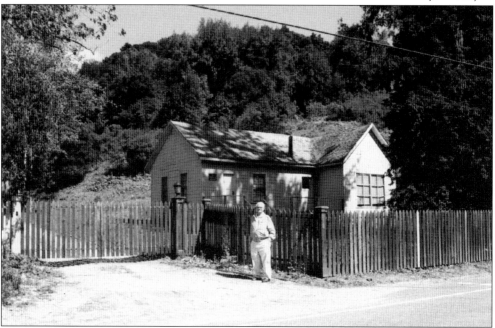

CANYON LEGACIES. Richard Warren, another Warren family descendant, stands in front of old Cull Ranch, where mountain lions, deer, and rattlesnakes still compete with ranchers to reign over its trails and fields. A few ancient, gnarled remnants of Cull's orchards still pepper the tops of the hills, and in spring one might yet catch a glimpse of the pink cherry blossoms or smell the sweet fragrance of pears and apricots.

WALTER CROW. Crow Canyon, which forms Castro Valley's northeastern edge and connects the valley to the San Ramon and Tri-Valley areas, was named for the Crow family, who arrived in the area in 1849. Walter Crow was the first to settle, and many of his descendants followed, each selecting a five-acre plot in the canyon to establish their ranches.

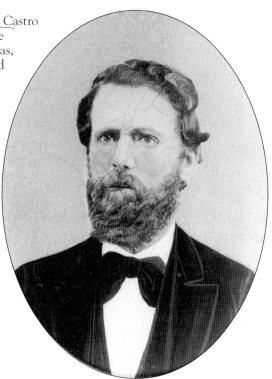

EVELYN CROW. Pictured here is Walter's wife, Evelyn, part of the large Crow family that resided in the canyon for many years. The Crows set out from Kentucky in the 1840s, traversing 2,500 miles across the country by ox-cart. The road through the canyon remained a treacherous, muddy, dirt path until the late 1920s, when it was fully paved, but even today heavy rains sometimes flood the narrow canyon route.

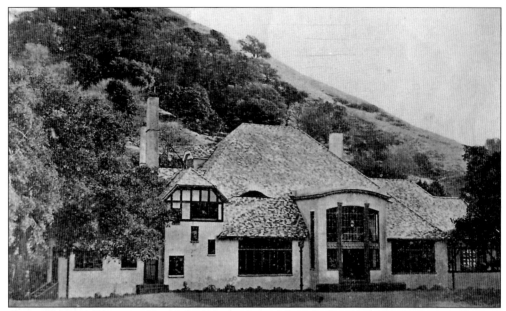

CROW CANYON CHATEAU. Established as a country club in the late 1910s, Crow Canyon Chateau became a popular speakeasy during Prohibition because of its proximity to Crow Canyon's many liquor stills. Across from the English Country-style structure was Crow Canyon Park, a one-time East Bay Water Company resort and later rest area for World War II servicemen, housing a collection of carousel horses from Neptune Beach and Sutro Baths in San Francisco.

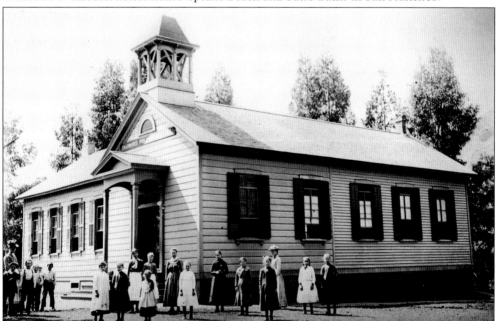

PALOMARES SCHOOL. Carved by the Palomares Creek, the canyon bearing its name winds south from the 580/East Castro Valley Boulevard corridor. Palomares School was established in 1868, near the site where William Hayward originally squatted on Guillermo Castro's land. The one-room schoolhouse opened with 34 children from grades one through eight in attendance, and the ubiquitous school bell at the top of the structure was added in 1896.

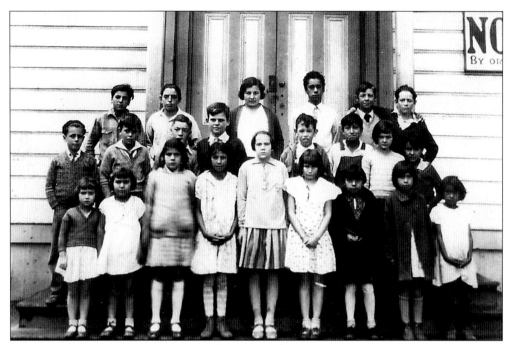

PALOMARES SCHOOL PHOTO. Many of the first families to settle and attend school in Palomares Canyon came from Portugal, and many still have descendants who live in the canyon today. Early names like Enos-Garcia, Texiera, Peixoto, and Pereira still grace mailboxes on the side of the winding Palomares Road. The long canyon forms the southeastern boundary of the valley, terminating in the Sunol-Niles area.

STONY BROOK SCHOOL, AROUND 1872. Palomares Canyon at one time boasted two schoolhouses, though the decidedly smaller Stony Brook, established in 1872, was actually designed to be portable, constantly relocating to wherever the student population was concentrated. The school never had more than eight students in attendance during any given term, and if the number ever fell below five, it was forced to close its door.

STONY BROOK SCHOOL, AROUND 1937. Eventually, the one-room school was secured to a solid foundation near the mouth of the canyon, along present-day Palo Verde Road. In 1937, it was stuccoed over and given a tile roof to emulate a Mission-style structure, a popular architectural form in California in the 1930s and 1940s. The tiny building became a private residence and is still lived in today.

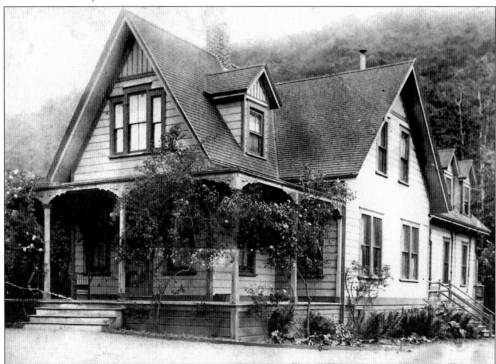

BONNY DUNE. The Bonny Dune Ranch in Palomares Canyon was once home to the Smyth family, and a descendant of the Smyths now operates the popular Westover Winery, one of several vintners along the road. Vineyards, as well as liquor distilleries, began to appear during Castro Valley's notorious Prohibition years. Chouinard Winery, just down the road, stands on the property of famed early sheep rancher Charles Cook.

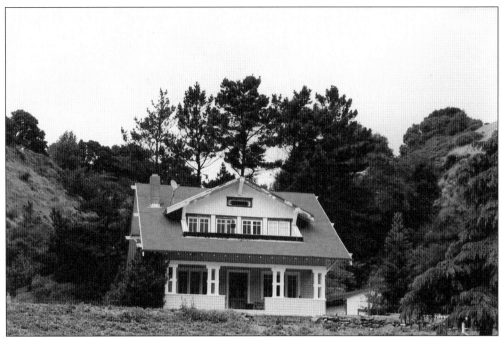

MAI HOUSE. Castro Valley's secluded Eden Canyon runs northeast off of the 580/East Castro Valley Boulevard corridor, continuing from the Palomares Canyon formation in the south. The Mai House was built at the mouth of the canyon in 1915, owned first by the Mai family and later by Joe Eastwood, uncle of actor Clint Eastwood, who moved the home to nearby Hollis Canyon.

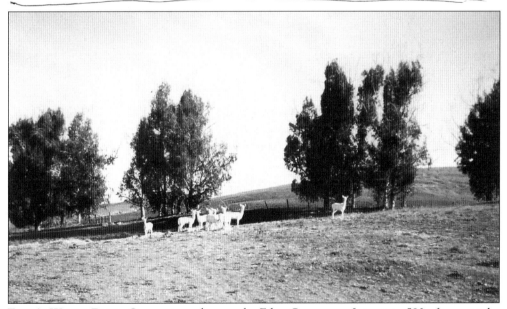

EDEN'S WHITE DEER. Commuters who pass by Eden Canyon on Interstate 580 often mistake these mysterious looking White Fallow Deer for goats grazing in the hills. In 1972, Steve Fields brought 10 head of deer from Oregon and they have since spread through the canyon. Steve descended from the Fields-Davilla families, who were some of the first settlers in the canyon and still live and ranch in it today.

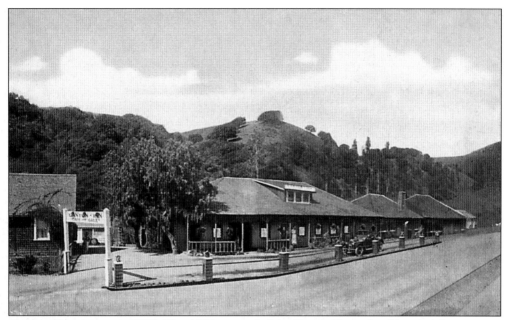

CANYON INN, AROUND 1915. This 1915 postcard of the Canyon Inn, a local hotel and restaurant, provides additional evidence of the valley's position as a transportation nexus. Located on the present-day Dublin Canyon Road/580 corridor northeast of Hayward, the inn served travelers headed to or leaving the Livermore Valley.

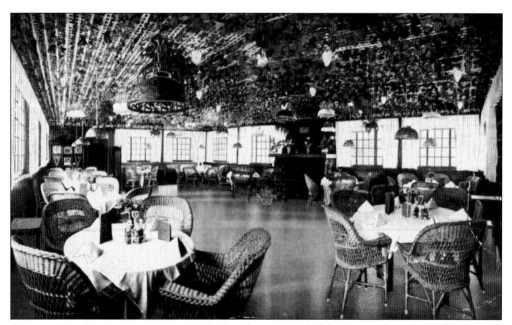

CANYON INN INTERIOR, AROUND 1915. Another postcard of the Canyon Inn shows the facility's main dining room. Seventeen miles from Oakland, the inn served regional travelers as well as local diners, and the lavish interior would have certainly pleased both.

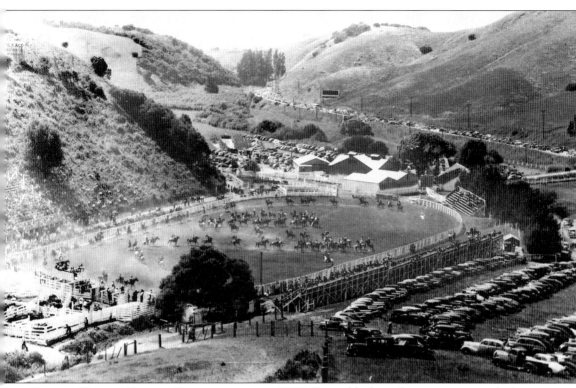

ROWELL RANCH, DUBLIN CANYON, AROUND 1950. Beyond linking the community with the sprawling Livermore Valley to the east, Dublin Canyon has served as the home of the Rowell Ranch and its famous rodeos for over 80 years. Dublin Canyon Road, now a frontage road adjacent to Interstate 580, was for many years the only access to the ranch. Every year people from all over the country flock to the canyon to witness the event and the rodeo-induced traffic jam is now a familiar site to East Bay commuters. In 1987, the rodeo grounds and 43 acres of surrounding ranchland became part of the Hayward Area Recreation and Park District. The rodeo grounds were completely refurbished in 1984, with a new arena as its centerpiece. This 1950s postcard attests to the dazzling, dusty spectacle of the annual event, now a popular stop on the Professional Rodeo Cowboys Association Tour. Associated events include the election of a rodeo queen to host the two-day extravaganza, and a popular chili cook-off and parade sponsored by the Castro Valley Rotary Club. Hayward Rodeo sponsors the rodeo.

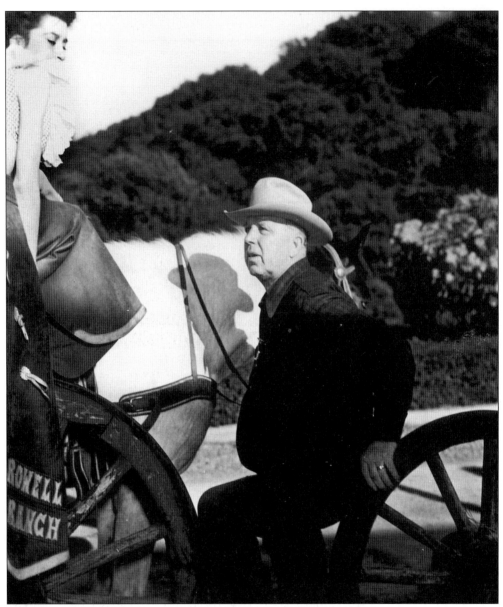

HARRY ROWELL. The rodeo was the brainchild of longtime Castro Valley resident and rancher Harry Rowell. Rowell was born in 1891 in Peterbourough, England, joining the Royal Navy at 15 years of age. Although there are many versions of Harry's arrival in the United States, the most accepted involves Rowell jumping ship from the HMS *Shearwater* while engaged in a 1912 survey mission in British Columbia. Rowell crossed the U.S.-Canadian border near Vancouver, and then headed south for California. Rowell worked and traveled throughout the East Bay, eventually deciding to enter the world of chicken ranching. When his Model-T delivery vehicle was involved in an accident, "scrambling" his precious cargo of eggs, Rowell entered the feed business by hauling dead animals and converting the meat into dog food and the ground bone into feed for the East Bay's massive poultry population. Soon an established rancher, Harry Rowell held his first rodeo on the grounds of Hayward's Burbank Elementary School in 1921. In 1925, the event was moved to Rowell's Dublin Canyon ranch, where it continues to be held every year.

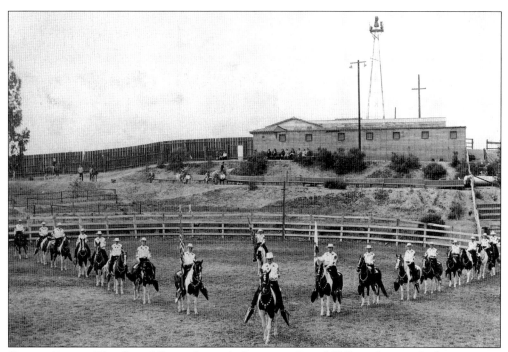

GRAND ENTRY. The Grand Entry descends from atop Signal Hill, as dozens of riders, wearing custom-made shirts and carrying colorful flags, kick off the annual event. Such an awe-inspiring spectacle, combined with the obstinate nature of Rowell Ranch stock, made Harry Rowell's rodeo famous. Rowell himself managed the show each year to the tune of his crowd-pleasing motto, "Give them a thrilling, spectacular show . . . AND MAKE IT FAST!"

REAL COWBOYS AND GIRLS. A group of ranch hands pose with their trusty rides. By the 1930s, Rowell was an expert rodeo producer and demanded that cowboys who entered the competition, many of them his own ranch hands, adhere to strict rules: no cheating, no discourtesy, no possession of alcohol while on rodeo grounds, arrive on the grounds by 10:00 a.m., and be ready to ride when called by the announcer.

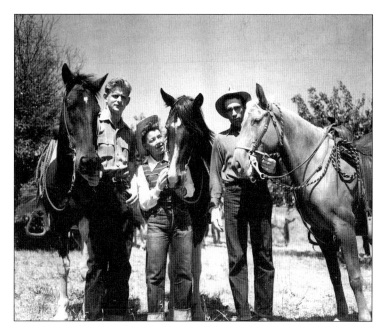

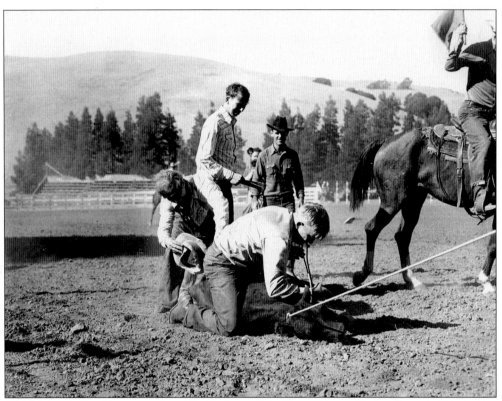

CALF ROPING. In addition to riding, the cowboys of the Rowell Ranch Rodeo showed off a number of other skills necessary in their line of work. Here, a participant puts the finishing touches on his roping job. Rowell cattle spent the winter grazing in the surrounding hills, and each spring local cowboys gathered to corral, rope, brand, and inoculate the ranch's bovine residents in a two-day roundup.

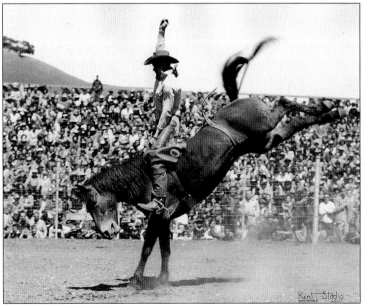

BUCKING BRONCO. This cowboy makes a valiant effort to stay atop a powerful bronco. The first rodeos in the Castro Valley region are indebted to Guillermo Castro and his vaqueros, who rounded up as many as 8,000 head of cattle for the ritual spring branding on the Rancho San Lorenzo. The roundup provided an opportunity for the region's vaqueros to demonstrate their skills in riding and roping.

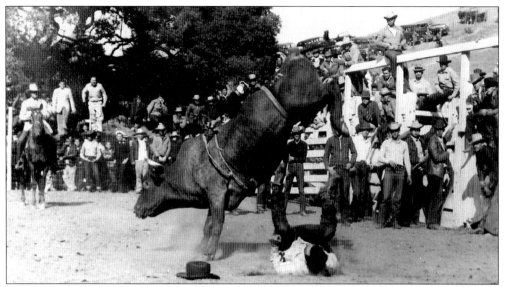

TOUGH STOCK. A bull rider gets some first-hand experience with one of Rowell's notoriously unrelenting steers. By the 1930s, the Rowell Rodeo had become an event known throughout the whole Bay Area. With his success in the Hayward-Castro Valley region, Harry Rowell went on to produce rodeos throughout the West.

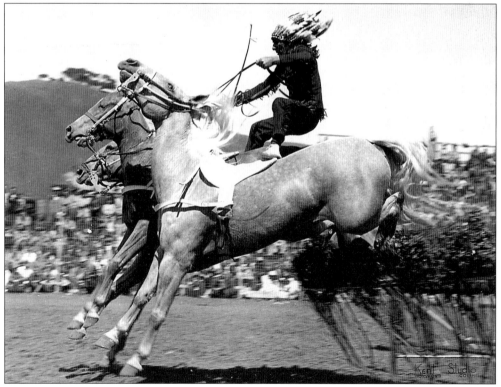

WILD RIDE. The rodeo featured an array of skilled horsemen and dazzling performances, as this triple-mounted showman attests. Many of the show-riders in the event came from all across the country and world, traveling the rodeo circuit with other such performers.

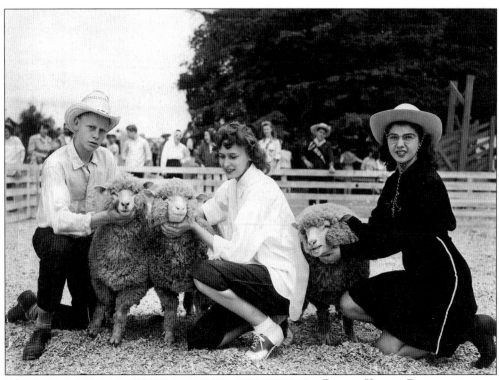

PROUD YOUNG RANCHERS.
Aspiring sheep ranchers show off
their stock, perhaps hoping to
someday follow in Harry Rowell's
footsteps. Local children from
the valley still participate in a
number of events and clubs that
focus on agriculture, nature, and
science, including the Boy and
Girl Scouts of America and 4-H
clubs.

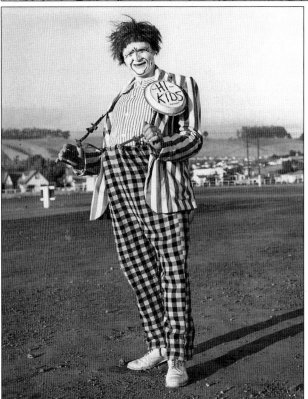

ROWELL RODEO CLOWN. This
friendly character is equally at
home attracting the attention
of adoring children or drawing a
one-ton steer away from a fallen
rider. A number of famous rodeo
clowns got their start at the
Rowell Rodeos, including Wilbur
Plaugher and film star Slim
Pickens, made famous by his ride
on a dropping atom bomb in
Stanley Kubrick's *Doctor
Strange Love.*

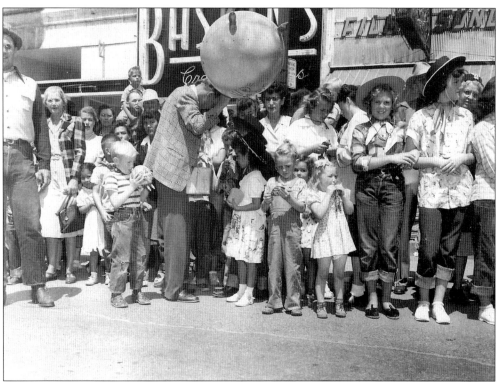

PARADE-GOERS. The Rowell Ranch Rodeo Parade came to Castro Valley in the early 1980s, where it has been held ever since. But the tradition began in Hayward in the 1920s with the rodeo-day parade and Western Week. Participants included marching bands, barrels converted into street broncos, military color guards, stagecoaches, and horses of all breeds mounted by an eclectic collection of riders.

LITTLE COWPOKE. Although this young man may not be ready to ride a bronco just yet, the Rowell Ranch began sponsoring its Junior Rodeo in 1963, testing the skills of broncobusters under 18 years old in 19 different events. In 1978, local rodeo enthusiasts helped form the Northern California Junior Rodeo Association (NCJRA), which sponsors competitions throughout the region. The Rowell Ranch played host to NCJRA's first finals in 1982.

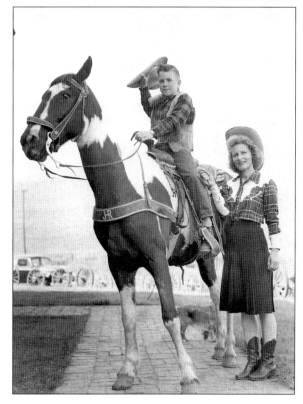

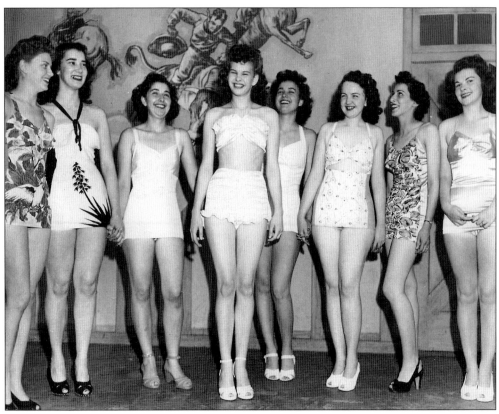

BATHING BEAUTIES. Rowell staged exquisite shows during the rodeo days, and a rodeo queen was elected to serve as hostess for the event, as well as participate in the local rodeo days parades of Hayward and Castro Valley. Today rodeo queens are chosen based on their performance in four categories: horsemanship, personality, appearance, and public speaking.

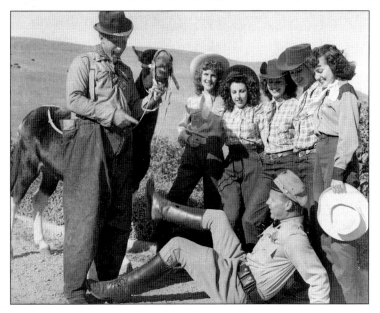

OFFICER DOWN. Rodeo participants poke fun at a California Highway Patrol officer, apparently thrown from his mount. Today the CHP participates in the rodeo by regulating traffic on the Boulevard and the canyons during the two-day event. Local CHP officers also drive their cars in the parade, thrilling spectators with flashing lights and startling sirens.

THREE GIRLS AND A GOOD SALESMAN. The helmets held by the girls indicate that they might have eschewed riding bucking broncos in favor of the tractor they are sitting on, driven by this salesman from Harvest-Aire. Today most advertisements found along the parade route are sponsored by local businesses.

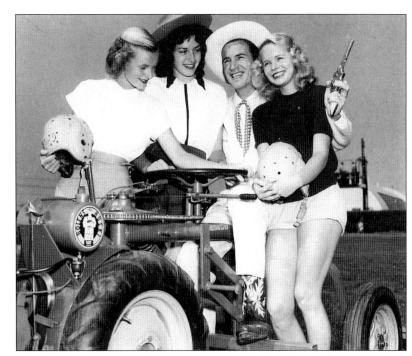

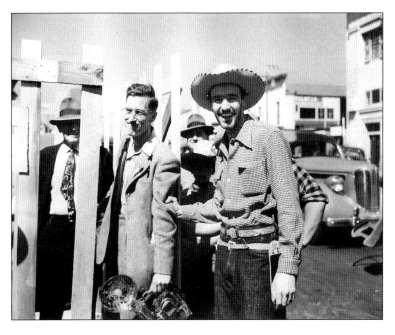

HAYWARD 20/30 CLUB MEMBERS. After sustaining injuries from a fall into a 450-foot ravine in 1950, Harry Rowell retired, and the rodeo's sponsorship was taken over by the Hayward 20/30 Club, a local social organization made up of community members under 40. Rowell agreed to remain as the event producer until 1957, when Cotton Rosser began running the rodeo.

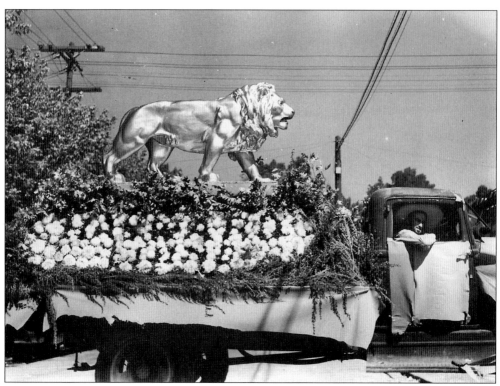

PARADE FLOAT WITH LION. Here a float, possibly sponsored by the local Lion's Club, prepares to join the parade. Today a number of the valley's oldest civic and social organizations participate in the parade, including the Lions as well as the Masons, Rotarians, Kiwanis, DeMolay, and of course the crowd favorite, the Shriners, in their famous mini-cars and fezzes.

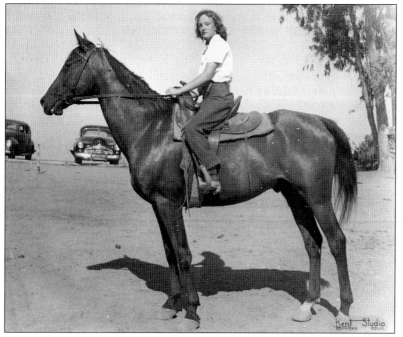

TOUGH COWGIRL. The rodeo wasn't only for boys. Cowgirls too participated in Rowell's shows, and Rowell's own daughter Elizabeth gained notoriety as an expert hunter and broncobuster. Here a local cowgirl strikes a formidable pose somewhere on the ranch.

Four

THE VALLEY
AND THE LAKE

Lake Chabot and its attached parklands on the northwestern side of Castro Valley have served the greater Bay Area for well over a century. Once known as Grass Valley and part of the Rancho San Lorenzo's vast reserve of grazing land, the only water apparent until 1874 were two small creeks. In that year, Anthony Chabot and his Contra Costa Water Company, utilizing the Chinese labor so vital to the development of early California, constructed the dam and its corresponding system of roads, tunnels, and filtration devices to bring water to the rapidly urbanizing East Bay.

With the creation of the East Bay Municipal Utility District (EBMUD) in 1928, and the East Bay Regional Parks District six years later, Chabot's 315-acre reservoir was converted to public ownership and residents clamored for recreational access. Finally opening in 1966, Lake Chabot became a center for outdoor enthusiasts, and its rapid acceptance into Bay Area hearts drove grassroots efforts to prevent residential development on the hillsides surrounding the reservoir.

Now considered a "natural environment" by most citizens, Lake Chabot is largely a human creation—its winding trails planned, and its ubiquitous palms, eucalypti, and rare Cork Oaks imported. Yet the lake itself is an engineering marvel and a testament to man's ability to alter the landscape. The surrounding area is also the enduring home of native species and ancient landscapes. This unique combination, a human brush over nature's canvas, has made Lake Chabot a treasure worth protecting.

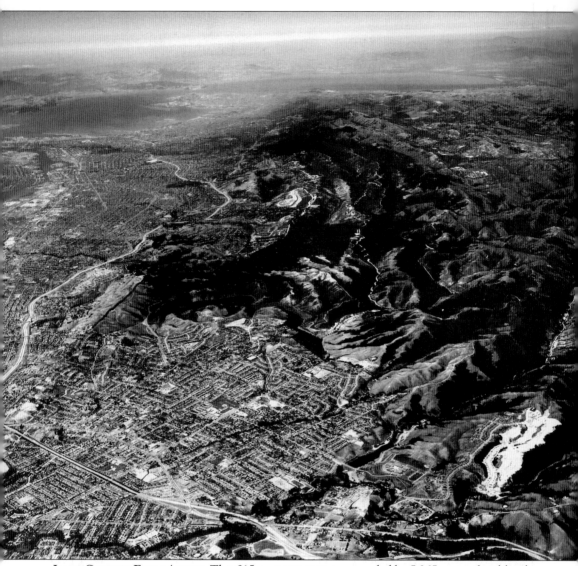

LAKE CHABOT FROM ABOVE. This 315-acre reservoir, surrounded by 5,065 acres of parkland on the northwestern side of Castro Valley, is a gathering place for families from around the whole Bay Area because of its natural beauty and ample public amenities. But before it was a park, or even a lake, the area was a sprawling, oak-lined valley with just two creeks bubbling through it that converged on the western edge of the present-day dam before spilling out to San Francisco Bay. Completely devoid of the stands of eucalyptus trees that now characterize its wooded atmosphere, the rolling green hills and dells were part of the bucolic cattle-grazing land of Guillermo Castro's rancho. After Castro sold his land, this lush region known as Grass Valley was divided by the early American settlers and transformed into fruit orchards and wheat fields.

ANTHONY CHABOT. A French-Canadian forty-niner turned hydraulic engineer, Anthony Chabot made a fortune in the gold fields in 1852 when he helped to invent the hydraulic mining cannon. In 1856, he left the gold fields for the Bay Area. He founded the Contra Costa Water Company and several others, as well as planned the dam on the edge of Castro Valley that now bears his name.

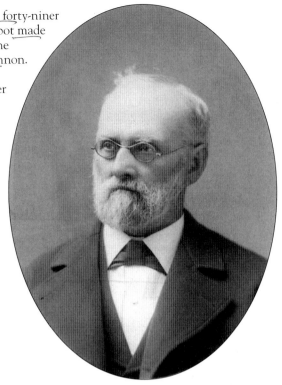

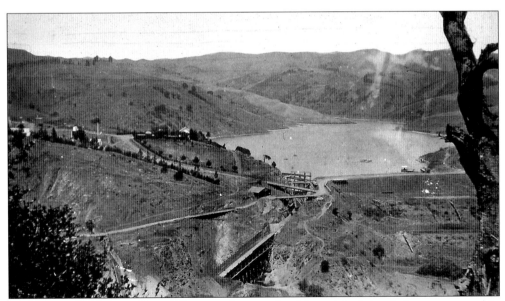

CONSTRUCTION OF THE DAM. This rare photograph of the original dam being constructed in 1874–1875 bears witness to the sheer magnitude of the project and some of the technology that went into its creation. Chabot's mining cannon was of course utilized to form the dam walls and passages, and his invention would earn him the title of the "father of hydraulic mining."

CHABOT'S HOME. A longtime resident of Oakland, Chabot built his final home there in 1882, shortly before his death. In 1874, he began construction of the San Leandro Reservoir, as Lake Chabot was then called, as a solution to Oakland's water shortages. Two years later his vision was achieved, as the reservoir's waters reached Oakland and San Leandro homes for the first time.

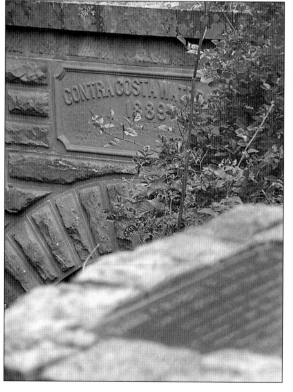

CCWC TUNNEL. Completed in 1889, one year after Anthony Chabot's death, this final tunnel outlet allowed excess reservoir water to flow back into San Leandro Creek. It sits behind a plaque honoring the work crew, who dug and dynamited through 1,438 feet of earth under the mountain to reach this outlet point. Chinese immigrants formed all of the crews working on the 18-year endeavor.

YEMA-PO. Oak trees, tall grass, and California poppies now grow in the steep ravine above the former Chinese labor camp. In 1979, a construction crew working in the area began to uncover Chinese artifacts, and through the extensive historical research of park ranger Jacqueline Beggs and a series of archaeological excavations led by the anthropology department at California State University East Bay (CSUEB), much more is now known about this Chinese encampment called Yema-Po. The name, meaning "wild horse slope," was chosen based on evidence that the dam was compacted by teams of mustangs imported by Chabot and driven by the Chinese. The archaeologists worked at the site during their field seasons in the early 1980s and again in the 1990s, uncovering over 60,000 artifacts that shed light on the diet, lifestyle, and work methods of the Chinese. Although looters destroyed large portions of the camp in the winter of 1980, anthropologists were able to salvage much of the site and discover more about life at the camp in subsequent excavations.

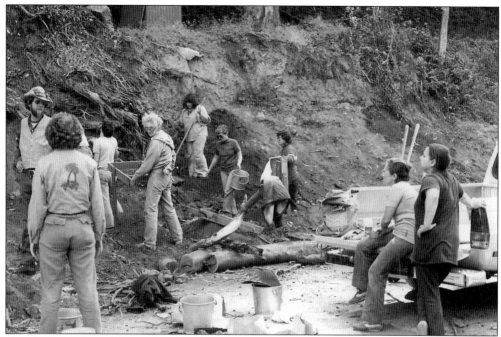

EXCAVATION. Professor George Miller (far left) led this dig along a slope during the 1981 field season. Many artifacts were found among the roots of the eucalypti, pine, and other trees, which characteristically cling to the embankments along many of Lake Chabot's trails. Also pictured here is Anne Gill (with sieve), one of three students to complete a master's thesis based on the findings at Yema-Po.

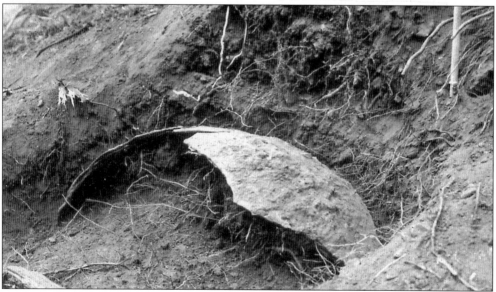

IRON WOK. The CSUEB Anthropology Department unearthed this large iron wok during one of their excavations in the early 1980s. The wok's tremendous size and relative position to what may have been a fire hearth, also uncovered during the excavations, seems to indicate that it was used communally. The anthropologists learned much about the Chinese workers' diets from animal bones found at the site.

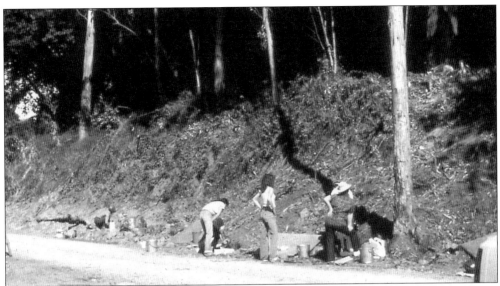

LEGACY REMEMBERED. CSUEB anthropologists presented research from the excavation at Yema-Po in their own museum, The CE Smith Museum of Anthropology at the Hayward campus, at an exhibit in 1994 titled, "Visions of Gum San: 150 Years of Chinese Experience in the Bay Area." The museum exhibits are updated frequently and open to the public, providing an invaluable resource for those interested in exploring the diversity of world cultures.

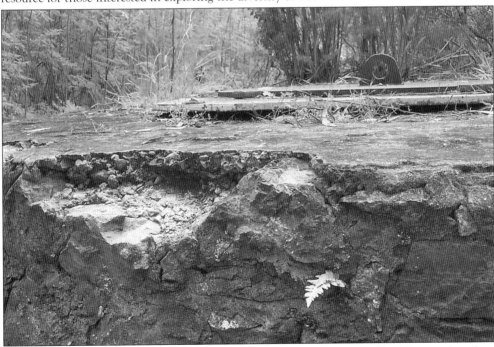

TUNNEL CAP. As many as 800 Chinese laborers forged the dam, as well as dozens of roads, a water filtration system, and three water-flow control tunnels (the "cap" of the first pictured here). Construction of these tunnels often proved a dangerous task and, during the course of the first and third tunnel projects in 1874 and 1889, collapsing embankments and faulty explosives cost six workers their lives.

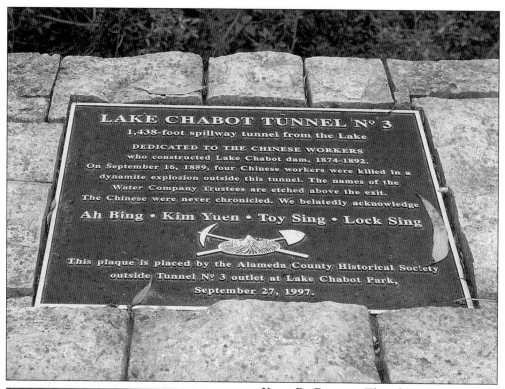

LAKE CHABOT TUNNEL Nº 3
1,438-foot spillway tunnel from the Lake
DEDICATED TO THE CHINESE WORKERS
who constructed Lake Chabot dam, 1874-1892.
On September 16, 1889, four Chinese workers were killed in a
dynamite explosion outside this tunnel. The names of the
Water Company Trustees are etched above the exit.
The Chinese were never chronicled. We belatedly acknowledge
Ah Bing • Kim Yuen • Toy Sing • Lock Sing

This plaque is placed by the Alameda County Historical Society
outside Tunnel Nº 3 outlet at Lake Chabot Park,
September 27, 1997.

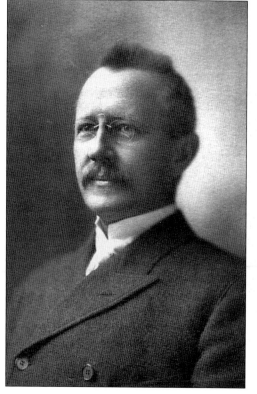

YEMA-PO PLAQUE. This plaque was erected in 1997 by the Alameda County Historical Society to honor the memory and achievements of the men who had worked, and sometimes gave their lives to complete the dam. The plaque is now one of many stops on the History Walk at Anthony Chabot Regional Park, which highlights points of interest through the history of the dam's construction from 1874 to 1892.

WILLIAM DINGEE. After Chabot's death, the Contra Costa Water Company eventually fell into the hands of another Oakland businessman, William Dingee. After his hostile takeover around the turn of the 19th century, Dingee made several aesthetic changes to the reservoir's landscape between 1904 and 1907, one of which was the famous Slate House that he commissioned the renowned Oakland architect Walter J. Mathews to design in 1904.

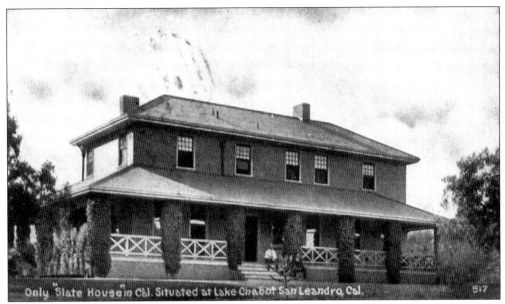

SLATE HOUSE. The aptly named Slate House was shingled entirely in slate from Dingee's Eureka quarry, and built for the superintendent who oversaw the reservoir's construction, replacing a much smaller home built near the dam in 1874. The stately home was occupied until the late 1940s but was demolished in 1950 after it had fallen into disrepair.

SLATE FOUNDATIONS. Shards of slate are still scattered among the oak leaves at the old foundations of the Slate House, which is yet another stop on Anthony Chabot's History Walk. With the once-stately structure decayed, and its creators long since passed, a young oak tree is now the primary resident of the site, often playing host to the songbirds and other woodland creatures that visit the ruin.

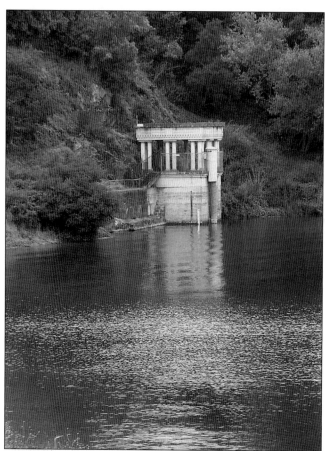

DIANA'S TEMPLE. This ornate, neoclassical tunnel cap was erected around the turn of the 19th century and still stands today on top of the first water-flow control tunnel, a testament to the industry, prosperity, and architectural tastes of the time. Throughout the 1910s and 1920s, the structures around the dam were often used for parties held by the water company for their employees.

POSTCARD OF LAKE CHABOT. This postcard, taken around 1909, shows the lake's appearance before the introduction of the eucalypti that form dense forests around Chabot's parkland today. The trees are a non-native species that was introduced to the area between the 1850s and early 1900s. Explanations of when and why the eucalyptus took root in Castro Valley are as prevalent as the tree itself.

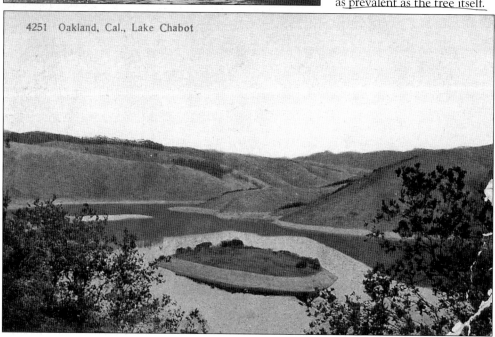

4251 Oakland, Cal., Lake Chabot

NORTH LAKE CHABOT ROAD.
Chabot himself may have been
responsible for introducing
eucalyptus to the area, and as
the owner of an arboretum, he
would have had access to such
exotic timber. The second water
company to own the reservoir
began planting eucalyptus
groves around the lake in 1910,
and this photograph from
the early 1920s attests to the
change of landscape in just a
few short years.

**ANOTHER POSTCARD OF
LAKE CHABOT.** Here again we
see what the lake looked like
before the eucalypti took hold,
around 1908. The fast-growing
trees were most likely intended
as a source of affordable
lumber, though their utility
was questioned when it was
found that their root system
was so extensive, any regular
orchard trees planted within
20 feet of them died, as the
150-foot giants drew away all
available water.

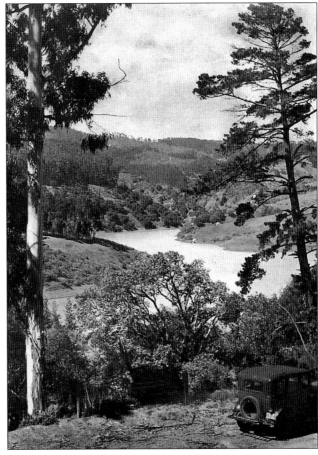

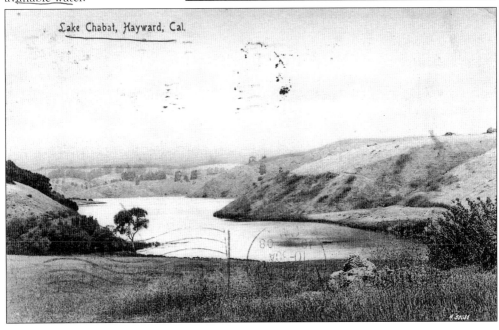

Lake Chabot, Hayward, Cal.

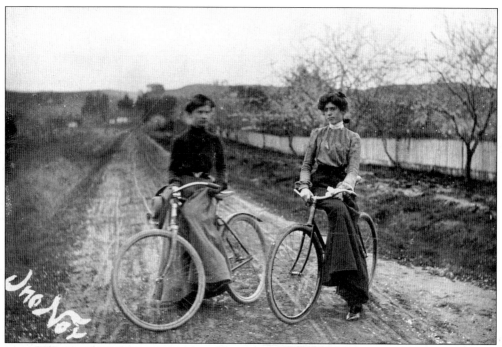

LADIES ON BIKES. Here we see two Castro Valley women out for a bike ride on Lake Chabot Road, probably around the late 1910s. The road was extended around the lake during the construction of the dam, providing another route from Castro Valley to San Leandro and Oakland, and no doubt transporting men and supplies to the dam project.

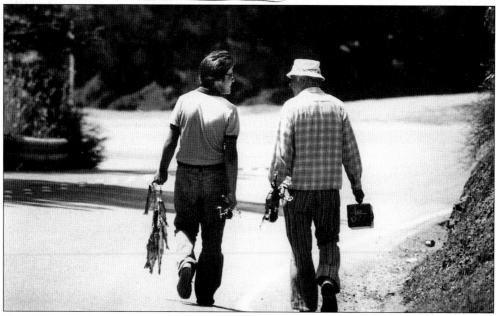

FISHY HISTORY. Jose DaRosa and Jay Pagan walk home from Lake Chabot after a successful day's work, fishing for the sought-after trout and other species of fish, like bass and catfish, which stock the lake. In 1855, Dr. William Gibbons of the California Academy of Sciences discovered a whole new species of steelhead trout in the watershed's tributary creeks, deeming them Rainbow Trout.

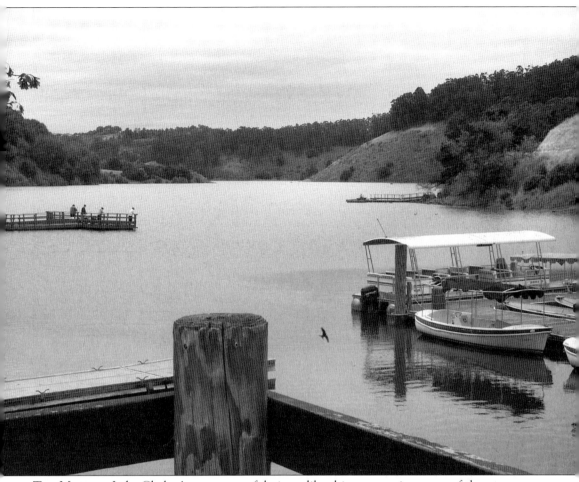

THE MARINA. Lake Chabot's many peaceful views, like this one, are just some of the reasons citizens of Castro Valley and Alameda County have worked so hard over the years to establish and preserve the lands around the lake for public enjoyment. When the ownership of the reservoir went public as part of the East Bay Municipal Utilities District (EBMUD) in 1928, surrounding residents began to put increasing pressure on the company to open the watershed to the public. In 1934, the East Bay Regional Parks District (EBRPD) was created to institute parks on surplus watershed land. Lake Chabot opened to the public in 1966 after 30 years of pressure from the community, and was operated by EBRPD under a lease from EBMUD. However, soon after the reservoir's opening, suburban sprawl threatened to overtake it and the park faced its greatest threats from proposed housing developments, beginning in the 1980s. It took the grassroots efforts of concerned citizens to stop these proposals, which threatened the surrounding ridges for over two decades.

FAIRMONT RIDGE. The first group of preservation-minded citizens to come onto the scene was the Fairmont/Lake Chabot Ridgelands Committee (F/LCRC), led by Gary Zimmerman, in 1984–1985, when a Naval housing development was proposed on Western Fairmont Ridge. The group successfully halted this proposal and worked with the EBRPD, helping them acquire the Lake Chabot side of Fairmont Ridge in 1987, which also might have otherwise been developed for housing.

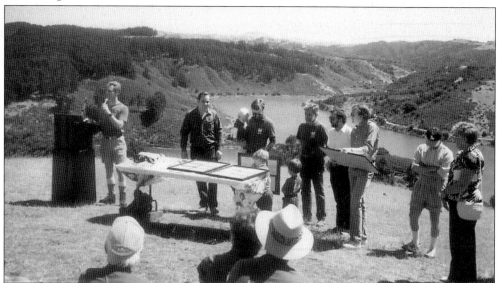

CELEBRATION ON THE RIDGE. The F/LCRC celebrates an early victory atop Fairmont Ridge in 1987 after EBRPD was able to purchase part of the threatened ridge. Pictured, from left to right, are Assemblyman Johan Klehs, Sen. Bill Lockyer, Erich Zimmerman (held), Gary Zimmerman (president of F/LCRC), Paul Zimmerman (child), Eric Pane (child), Al Chammaro, Cliff Sherwood, Alameda county supervisor Bob Knox, Hayward mayor Mike Sweeney, and San Lorenzo School Board member Betty Moose.

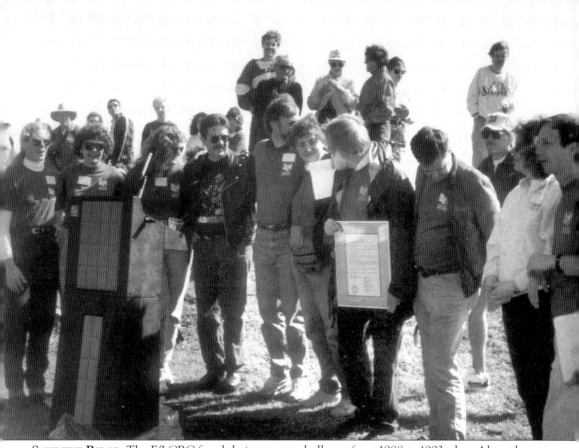

SAVE THE RIDGE. The F/LCRC faced their greatest challenge from 1988 to 1993 when Alameda County and the City of San Leandro proposed a development on Western Fairmont Ridge, with plans to annex the area to San Leandro. The county would have had the power to approve their own plan had this group not challenged them. In 1988, the F/LCRC worked with the EBRPD on Measure AA, a regional park acquisition bond measure. A sizeable portion of the bond money was allotted to the purchase of the county property on Fairmont Ridge, though the county would not officially withdraw the housing proposal until the sale to EBRPD was announced in 1993. The F/LCRC also hired geologists, botanists, and entomologists to analyze and assess the area's environmental significance. Not only does the Hayward Fault run straight through West Fairmont, but it was also found to be a "serpentine area," a geologic phenomenon which prevents non-native plants from growing. The experts subsequently found two extremely rare California native flowers, and discovered the Fairmont Blind Harvestman, an insect found only on this ridge.

DUNSMUIR. From 1986 to 1996, these oak-carpeted hills north of Lake Chabot witnessed yet another preservation battle. Surrounding residents formed the Dunsmuir Ridge Alliance (DRA), choosing resident Paul Merrick as their primary spokesperson, and together they coordinated busloads of residents to attend public hearings throughout the 10-year period. In 1989, their numbers nearly reached 1,000 at one such meeting, and in 1996 the Oakland City Council unanimously denied the project.

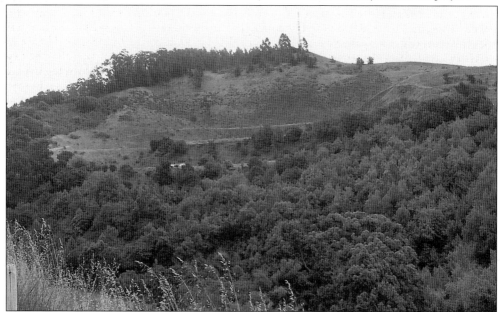

OLD QUARRY. The most recent preservation efforts, spanning the years from 1989 to 1998, concerned this old quarry overlooking the western edge of the park. After the City of San Leandro approved the first proposed housing project, a group of citizens called the San Leandro Coalition for Responsible Planning (SLCRP) organized one of the only referendum drives in city history, demonstrating to the government and the developer that public opinion was overwhelmingly against them.

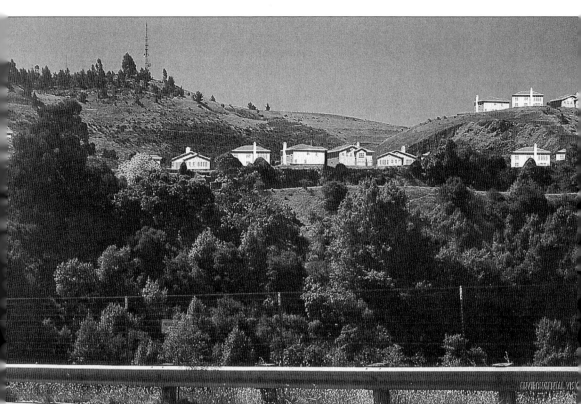

OLD QUARRY EIR. This second image of the quarry, depicting super-imposed homes at the site, was developed by the SLCRP in 1997. It was submitted in their revision of the site's Environmental Impact Report (EIR) to show the visual influence that the housing development would have as seen from one of the park's most heavily used trails. The group produced the picture after the city and developer had issued a similar, but less-realistic image in the first EIR, in which the impact of the housing was downplayed through creative shadowing effects. When a San Leandro city council member told the group that perhaps park-goers would enjoy seeing upscale homes on the ridge, they surveyed over 100 visitors, and nearly all of them were against the development. In the winter of 1998 this housing proposal was delivered its final blow, with both public opinion and nature seemingly against it. El Niño's torrential rains washed away half of the prospective building sites.

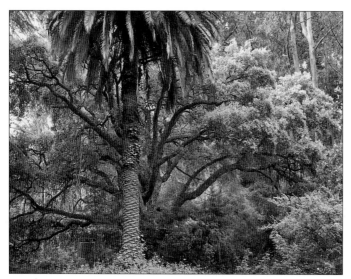

CORK OAK. This rare Cork Oak stands in a quiet, deeply wooded corner of the park, protected along with a lonesome Palm Tree and surrounded by eucalypti. Both trees are non-natives, and like the eucalyptus, details of their arrival are unknown. Though the trees were artificially introduced, like the lake and much of the wilderness that surrounds them, their beauty and significance to the community have made them worth protecting.

THOMAS, MICHAEL, AND OMAR. Out for a walk on a quiet morning at the lake, brothers Thomas and Michael White enjoy their time on the trails with their dog Omar. The central location and serene beauty of the park have made it an accessible and important part of many residents' everyday lives.

Five

THE HEART OF
GOOD LIVING
1940–1960

A village of roughly 4,500 in 1940, World War II changed Castro Valley forever. California's population surged from 7 million in 1940 to 10 million a few years after the war's end. New industries sprang up throughout the Bay Area, and the resulting prosperity, federal support for home ownership, and a pronounced increase in the national birth rate transformed many of the East Bay's agricultural regions into bedroom communities.

Locating new families, the Castro Valley Chamber of Commerce announced, was the community's "newest industry." Local promoters touted the area's hillside homes for country-style living and the 22 shops of the Castro Village Shopping Center. The community's new Eden Hospital, with its busy maternity ward, placed the valley at the head of the baby boom by reporting more births than any other Bay Area hospital. The valley's population, which jumped 400 percent in the 1940s, continued to climb, and by the mid-1960s the once sleepy poultry region claimed 54,000 residents.

Much of the population growth was attributed to geography, as residents found ready links between employment centers and Castro Valley homes. Construction of a freeway through the Dublin Canyon relieved the traffic pressures along the Boulevard and facilitated the transformation of rolling hills and former grazing lands into sprawling subdivisions.

But the new urban landscape never completely overtook the beauty of the canyons, the hills, and the splendor of Lake Chabot. That coexistence truly makes Castro Valley "the heart of good living."

FIRST CASTRO VALLEY SIGN. Longtime residents of Castro Valley remember this slogan from the community's first sign that stood in old town on the Boulevard from the 1930s to the 1950s. It welcomed visitors and Castro Valley residents into an era of growth and prosperity, while still paying tribute to the city's rural roots. No matter how much Castro Valley grows, its inhabitants maintain their close-knit, small-town sensibilities.

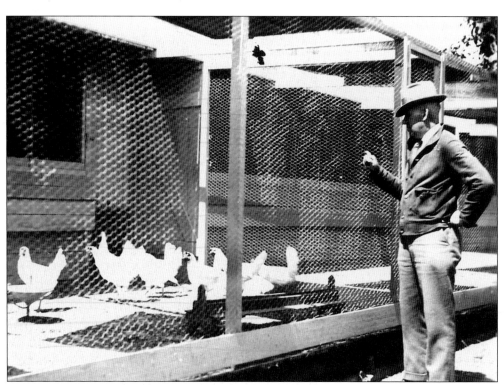

CHICKEN FARMER. For the first half of the 20th century, Castro Valley's chicken production was second in the world only to Petaluma, thanks to the hard work and perseverance of its farmers, like this unidentified man from the late 1940s. At its peak output, the city boasted 12 hatcheries and countless ranches, which supplied not only the Bay Area, but the world with their stock.

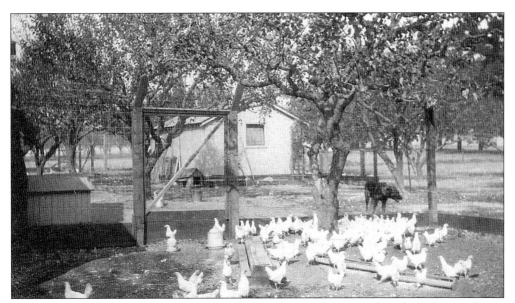

MORE CHICKENS THAN PEOPLE. A hungry-looking dog watches over a brood of White Leghorns on a typical family farm in the late 1940s, perhaps sensing that he'd best grab a free meal while he still can, because the era of chickens outnumbering people was quickly vanishing. Although the Leghorns had been the town's most prominent demographic for over two decades, the baby boom would soon change everything.

NEW CONSTRUCTION. A new home is framed out and nearing completion on a small lot behind an already existing, older structure. This was the typical mode of Castro Valley's first wave of housing development in the late 1940s and into the 1950s, as large family farms and ranches were subdivided to accommodate new residents.

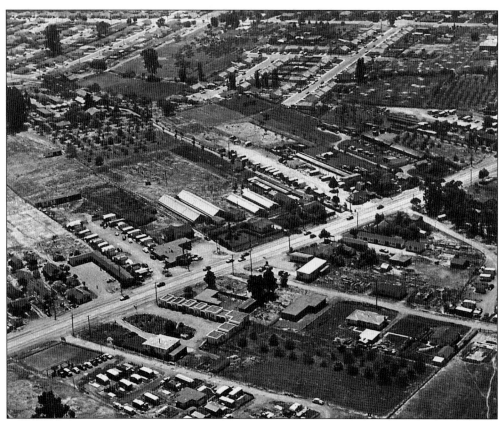

BARNS AND BUNGALOWS. Another typical sight in the late 1940s and early 1950s in Castro Valley were these long chicken barns, standing side-by-side with small mobile or row homes, as this aerial view of the Boulevard attests. At this time, the Boulevard was actually part of U.S. Highway 50, one of the nation's first transcontinental highways, established in California in the 1920s.

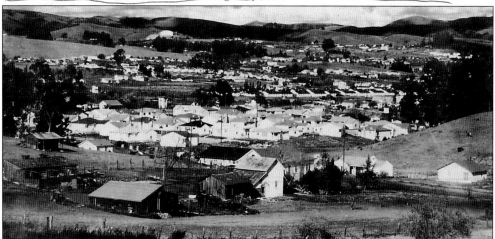

KNOX HOUSING TRACT. The Knox development, one of Castro Valley's first large-scale, planned housing tracts, was constructed soon after the end of World War II. Nestled in the hills on the far southwestern side of the valley, the modest little bungalows peer back into the developing landscape, ready to accommodate the burgeoning community.

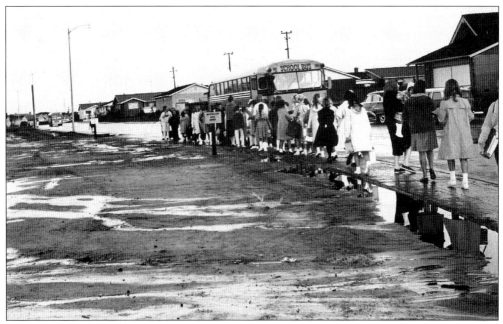

THE BUS IS HERE. Dozens of school children pile onto a bus on a rainy morning as doting mothers enter the mix to give one last embarrassing goodbye kiss, or perhaps to restore a forgotten lunch box. Although the housing tract is yet unfinished, there are more than enough families with children to fill not one, but two school buses, as another winds its way down the lane.

BUSY INTERSECTION. This 1951 photograph of the intersection at Center Street and the Boulevard may look slow-paced to anyone familiar with its cross-traffic today, but even the relatively sparse developments shown here were vast improvements over the previous roads. Old and new roads had all been fully paved by the 1950s, and telephone wires even began to run all the way out to the Canyons in East Castro Valley.

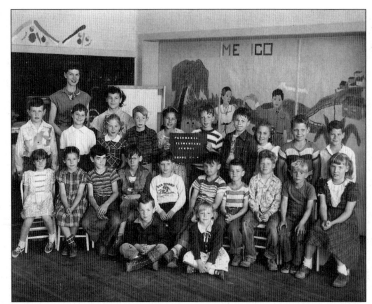

UNDERCLASSMEN. As Palomares School acquired more students throughout the years, it finally became necessary to replace the old one-room schoolhouse built in 1868 at the mouth of Palomares Canyon. The new building opened in 1955 directly behind the old structure, just a stone's skip over Palomares Creek, nestled against the canyon's western hillside. This photograph shows one of the first classes to go through the new school.

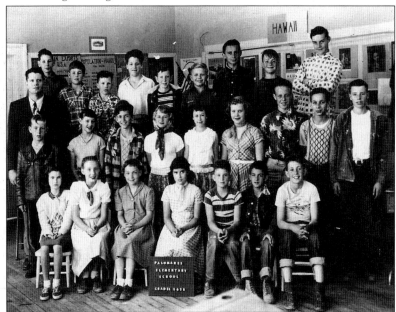

UPPERCLASSMEN. Palomares long served grades one through eight, and was traditionally divided into the underclassmen of grades one through four and upperclassmen of grades five through eight. As Castro Valley's other schools developed, it was eventually limited to one through five, now boasting just 128 students. With the exception of a few cuffed indigo Levi's and plaid sundresses, the smiling faces and cowlicks of these youngsters make it look as if this picture could have been taken yesterday.

A BATTLE OF WITS. Two young scholars spend their recess playing an intense game of chess on the playground, just behind the baseball diamond at Palomares School. Shortly after the opening of the new building in 1955, teacher Frank Schwarz added chess to the underclassmen's curriculum. Student Danny Turner is seen here on the right.

APPLIED LEARNING. It seems no one needs to tell these self-motivated learners that Castro Valley has always held education in the highest esteem, and that its first schools, Eden Vale and Redwood, were founded and funded by early settlers for their children. The scene brings to mind the old proverb, "A society grows great when old men plant trees whose shade they know they will never sit in."

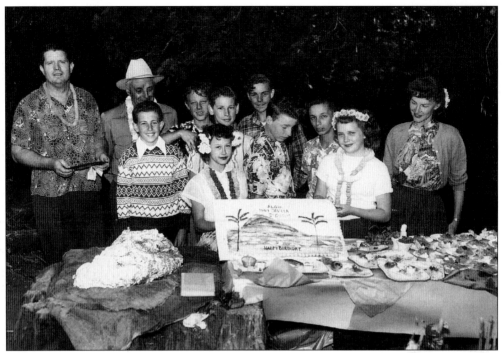

TO TONY, WITH LOVE. Palomares schoolteachers Lois and Frank Schwarz join students to celebrate with longtime Castro Valley resident and school trustee Tony Davilla on the occasion of his retirement. The students had completed a Hawaii unit during the school year and were able to show off all they had learned by throwing Mr. Davilla an authentic luau, complete with ukulele music, dancing, and a not-so-authentic frosted cake.

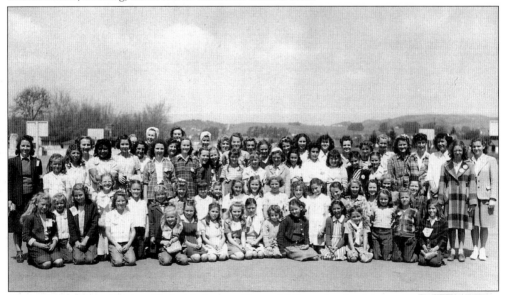

GIRLS' PLAY DAY. Unidentified girls from a Castro Valley school celebrate Girls' Play Day, an event during the school year that allowed them to relax and participate in a variety of outdoor activities. As the number of students boomed in the 1950s, more schools were built and grade divisions rearranged to suit the masses of incoming children.

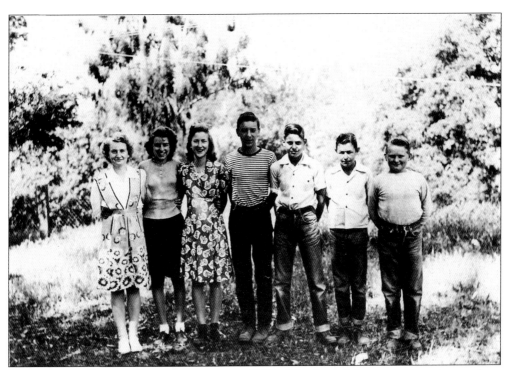

INDEPENDENT SCHOOL GRADUATES IN THE 1940S. The first of these two class pictures from Independent School represents an entire graduating class from the 1940s.

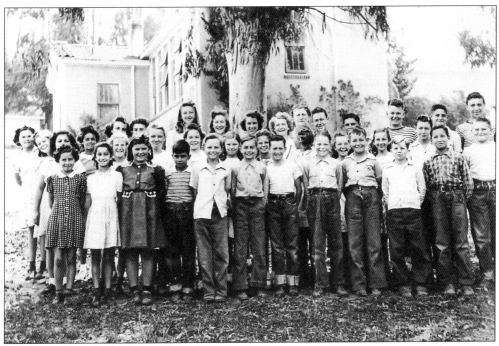

INDEPENDENT SCHOOL STUDENTS IN THE 1950S. This larger class photograph, taken on the same day as the previous image, shows the entire student body of Independent School.

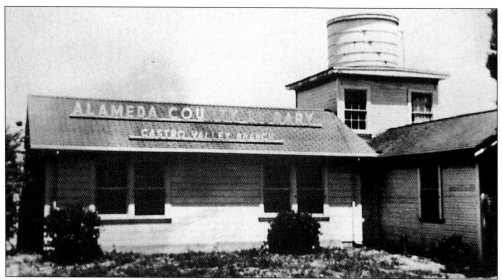

CASTRO VALLEY'S FIRST LIBRARY. It turns out that the story about Castro Valley's first library being quartered in a chicken coop wasn't just a tall tale. Originally a chicken-wire brooder and tank house on the Boulevard, this structure was converted into Castro Valley's first book deposit station in 1918.

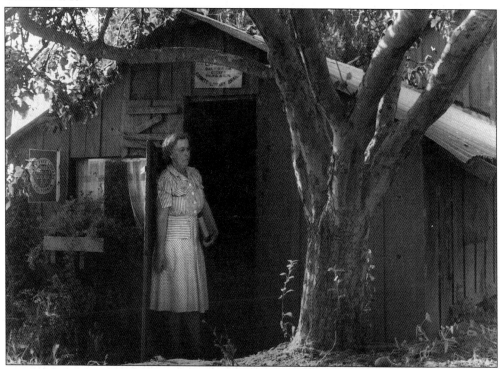

LOCAL LIBRARIAN. Mrs. Due, who served as a Castro Valley library attendant for 47 years, stands in the doorway, seemingly awaiting the after-school rush. The old apple tree provided shade and a cozy place to read, and the hours posted above the door would indicate that this was the best place to get some homework done after school since it was only open daily from 2:00 to 5:00 p.m., except Thursdays and Sundays.

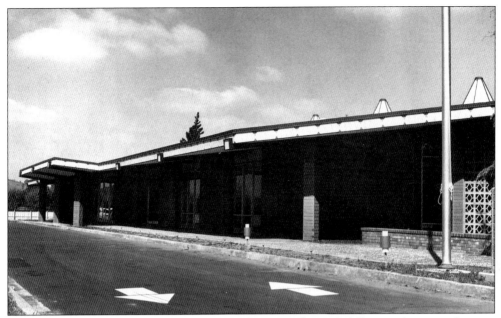

A LIBRARY FOR THE MODERN AGE. During the years of growth following the war, it became evident that Castro Valley had outgrown the old chicken coop, and in 1962 this new ultra-modern structure with a collection of 23,644 books took its place. At a cost of $232,000, the library had ample lighting and seating, and plenty of room to grow.

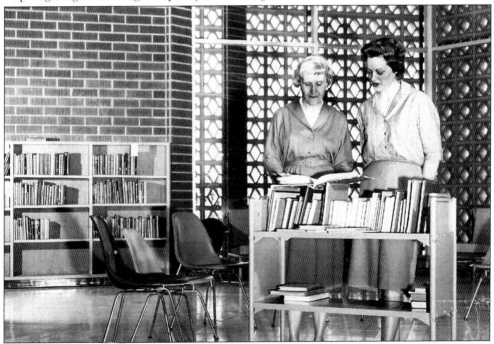

PAST AND FUTURE LEGACIES. An older librarian is seen here chatting with a younger colleague, perhaps imparting wisdom and advice for the years to come, at the opening of the new library. In recent years Castro Valley has even outgrown this structure, and a new state-of-the-art library with space for a 60 percent larger collection of materials is set to break ground in 2009.

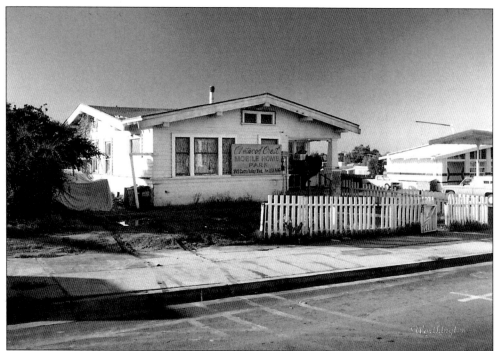

CHETWOOD CREST. Like many of the old buildings on the Boulevard, Castro Valley's early row and mobile home grounds have weathered many of the changes that the city has experienced. This small bungalow, which serves as the office for one such community, fell into disrepair during the 1960s but was saved and lovingly restored to an even better-than-original state, and still functions as the Chetwood Crest park office.

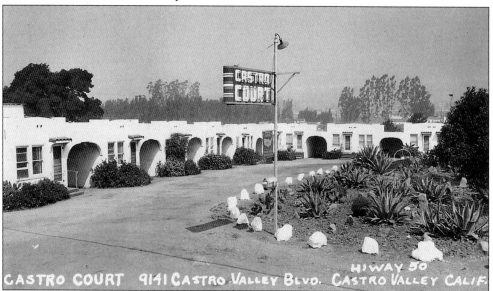

CASTRO COURT. This postcard from the late 1940s (note the dual address listing, "Castro Valley Boulevard," and "Hiway 50") shows one of Castro Valley's first motels. After World War II, more Americans would begin to purchase cars and travel, and such structures would begin to appear along the whole length of the Boulevard.

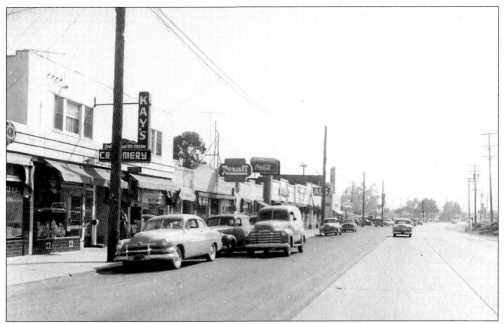

WHEN "OLD TOWN" WAS NEW. Very little has changed aesthetically about this segment of the Boulevard since 1950, when this photograph was taken, save a few soda fountain and drugstore signs and one or two extra-wide chrome bumpers. Note that the dark tile on the storefront next to Kay's Creamery can still be seen today, looking quite up-to-date and stylish, gracing the façade of new boutiques and specialty stores.

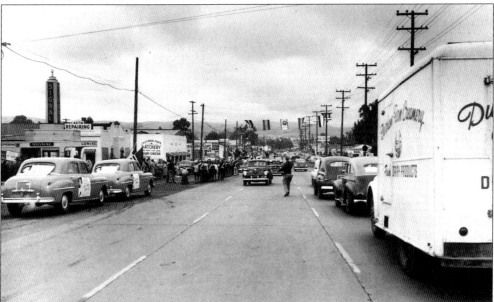

THE BOULEVARD. A parade marches east on the Boulevard under a banner of Italian flags, perhaps celebrating the heritage of some of Castro Valley's early Italian families. The scene as a whole gives an indication of the town's current situation. Real estate signs blazoned on the south side of the Boulevard oppose chicken hatcheries on the north, while the townspeople move about the center, attempting to navigate the wisest course.

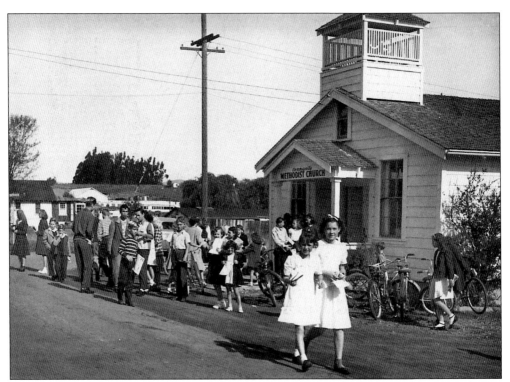

SUNDAY SCHOOL. A large group of children congregate outside the Community Methodist Church on a Sunday morning after service lets out. The population boom in the 1950s not only meant more homes in Castro Valley, but more governmental, social, and religious institutions as well. The city now boasts dozens of churches of differing denominations, but because most were constructed during the 1950s and 1960s, many share their distinct mid-century architecture.

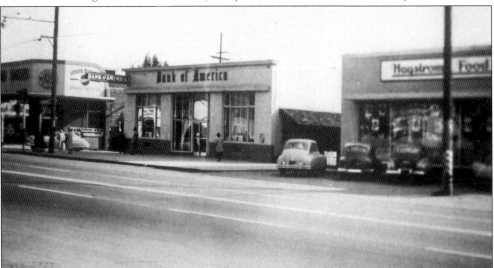

BANK OF AMERICA. Perhaps one of the most significant indicators of the coming economic prosperity in the 1950s for any small town in America was the arrival of the city's first big bank. Castro Valley reached this milestone with the opening of the Bank of America. A steadfast institution for over 50 years, the bank is still on the Boulevard today, at its original location.

LUMBER SUPPLY. Adding machines and catalogs from California building supply companies adorn the desks of Clarence Elsworth and Robert Wilson, owners of Elsworth Wilson Lumber in Castro Valley, which later became Castro Valley Lumber. Pictured here in 1952, in the midst of Castro Valley's greatest housing development boom, it is easy to imagine why the smiles on their faces are as wide as the brims of their fedoras.

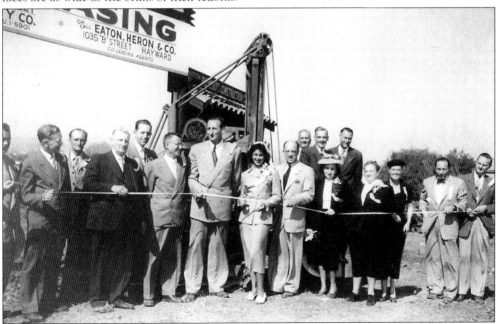

A CASTRO VALLEY LEGACY BEGINS. Construction on the Castro Village Shopping Center broke ground in the late 1940s, and seen here is the ribbon-cutting ceremony featuring prominent businessmen, designers, and developers. Arnold Anderson, a local real estate agent, envisioned the center years earlier and purchased the tomato field at the corner of Santa Maria Avenue and the Boulevard with his mother and another property broker.

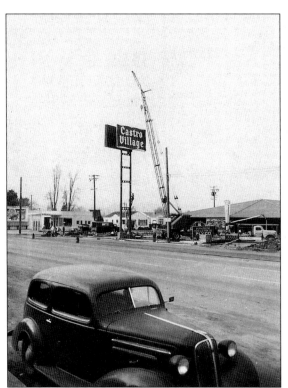

A SWELL PLACE TO TAKE THE OLD JALOPY. A familiar silhouette takes shape as the Village's low roof line is completed and a crane assembles its towering beacon. The shopping center came to Castro Valley at a time when increasing numbers of Americans could afford cars, thus vehicle-oriented shops, restaurants, and motels began to appear everywhere. The Castro Village was the perfect place to show off your old 1936 Chevy jalopy.

THE GRAND OPENING. A group of residents and new shop owners celebrate the Village's completion in 1951, under its characteristic rustic redwood eaves, in front of what is today one of the city's most popular gathering places, Starbucks Coffee. A white-flocked Christmas tree is also there to witness the scene, indicating that the shops probably opened just in time for the holidays.

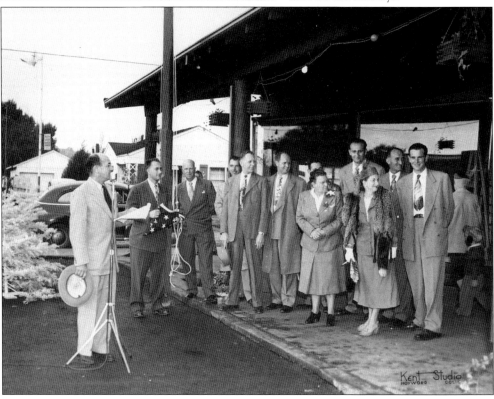

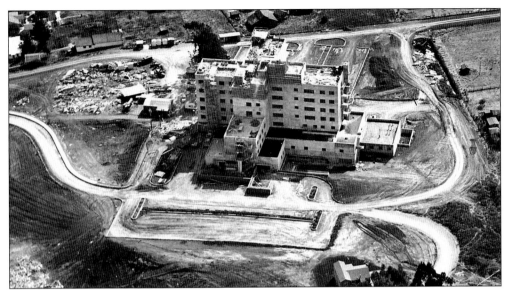

EDEN HOSPITAL. Along with the arrival of large-scale banking establishments and a planned city center, the establishment of Eden Hospital from 1951 to 1954 signaled a time of new growth and prosperity for Castro Valley. Eden quickly outgrew its original structures, reporting more births than any other Bay Area hospital, and in 1957 it was enlarged and still continues to expand along with the community.

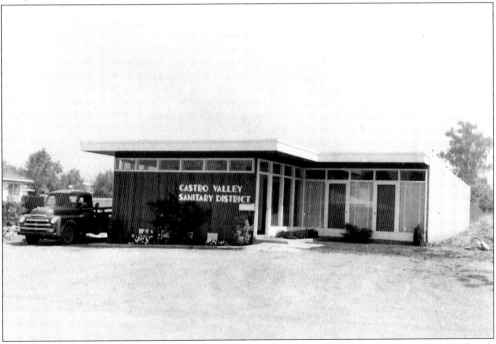

THE CASTRO VALLEY SANITARY DISTRICT. Because Castro Valley is an unincorporated city, several other local agencies and utility districts have served in leadership capacities throughout the years. The Castro Valley Sanitary District, established in 1939, is one such institution, with many of the city's most prominent citizens having served on its board, and pioneering one of the most progressive recycling programs in the nation.

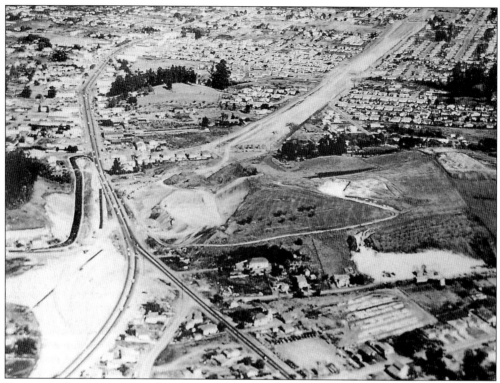

FREEWAY CONSTRUCTION. Between 1940 and 1950, Castro Valley's population went from 5,000 to over 20,000 people, and the Boulevard became so overcrowded that it could no longer function as the East Bay's sole thoroughfare to and from the Central Valley. The new freeway alleviated the Boulevard of its function as Highway 50, leaving it open to support the masses of new residential traffic.

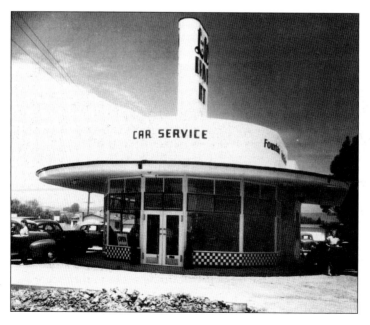

THE L&W DRIVE-IN. Like most Americans in the 1950s, Castro Valley's love affair with the car started early and continues today, sometimes in the form of a "show and shine" at the high school, and other times in a good old-fashioned cruise down the main drag. The L&W Drive-In was a popular hangout on the Boulevard, attracting the town's youth for a milkshake served right at the window of Dad's sedan.

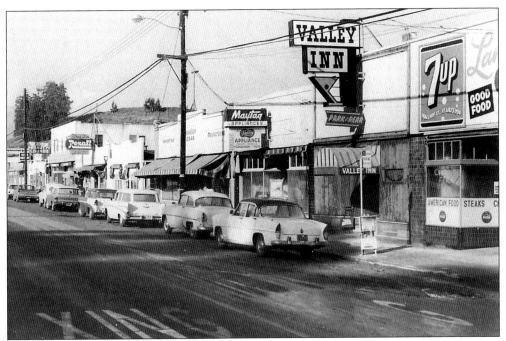

THE VALLEY INN. The mobility of Castro Valley's new population created the desire for auto-accessible businesses, as well as new parking lots for older businesses, which could accommodate far more people than street parking alone. In another slightly questionable bit of local automotive history, we see some of this progressive business spirit at the Valley Inn, which advertises a place to "park in rear," for taxicabs of course. "Old Town" still looks much the same.

PERGOLA HILL. Pergola Hill, as local motoring lore has it, was once called Buhmer Hill after an early family in the area, but was cleverly deemed Boomer Hill by the area's hot-rodding youths. After the long canyon-run from the Tri-Valley to the Eden Townships, kids in their souped-up 1932 Ford Deuces and brand new Tri-Fi Chevys would come booming out of the end of the canyon and into Castro Valley. P. W. Market Place is now at this location.

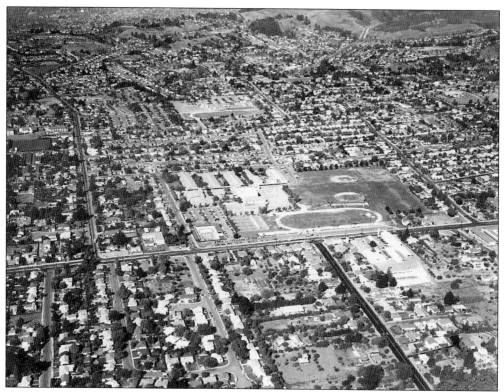

CASTRO VALLEY HIGH SCHOOL. In 1956, Castro Valley High School (CVHS) opened just in time to welcome one of the first waves of the city's baby-boom generation as they reached high school. Here is an aerial view of the state-of-the-art school shortly after it opened, only a few feet from where Brickle's first Redwood School was built 90 years earlier.

RIBBON CUTTING AT HAYWARD HIGH, 1949. Pictured here at the opening of the new boys gym at Hayward High, now Centennial Hall, is local educator Carlos Bee with students, from left to right, Maggie Winkler, Bonnie Englum, and Lucille Thomford. For many years before CVHS opened, high-school aged children from Castro Valley were bussed to Hayward High School, which was on the border of the two cities.

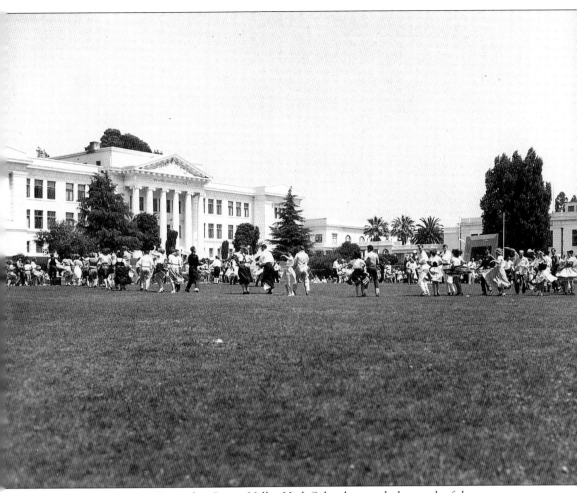

SEE YOU AT THE HOP. Even after Castro Valley High School opened, the youth of the two towns socialized at gatherings like this one on the front quad of Hayward Union High School. Given the outdoor setting, one can hope that more than just the standard "socks" were the footwear of choice at this "hop," as kids twist and shout and poodle skirts seemed to be blooming like daisies on the lawn. Bill Haley and the Comets are often credited for kicking off the Rock and Roll era when their song, "Rock Around the Clock," was played over the opening credits of the 1955 movie *The Blackboard Jungle*. The following year, Elvis Presley's first single, "Hound Dog," hit the airwaves, but kids around the valley wouldn't have a Top 40 radio station to catch him on until 1957, when KOBY 1550 AM was launched as the Bay Area's first rock-and-roll broadcaster.

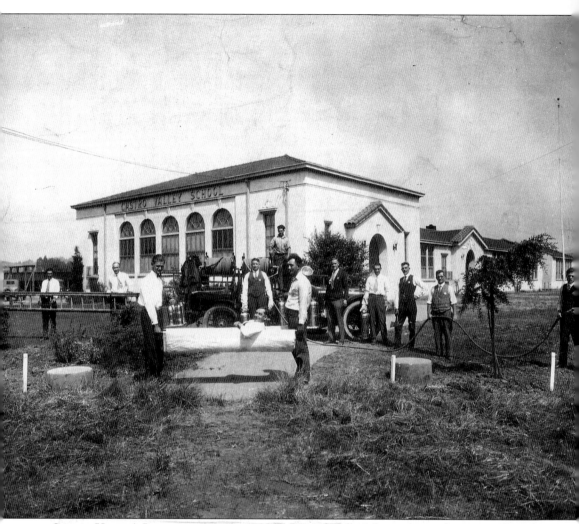

CASTRO VALLEY'S LEGACY OF FIRE PROTECTION. Castro Valley's fire protection history nearly spans the whole story of the town itself, and this 1929 roster of the community's first fire company reads like a who's-who of the early valley. Pictured, from left to right, are Will Wolters, A. Christensen (stretcher), G. Gonzalves (rear), Jack Gonzalves, A. B. Morris, Orin Crowe, Jess Morier (in truck), Jerry Unser, Al Nunes, Pete Selmeczki, J. Stanton, Appleby, and O'Kine. The fire truck in the background was the former Winston Touring Car of Jerry Unser, father of renowned racecar drivers Bobby and Al Unser, and Castro Valley's first fire chief. After a friend of Unser's crashed the car into a ditch, he decided to refurbish and modify it to serve as Castro Valley's Volunteer Fire Department's first fire engine. When the station alarm sounded, volunteers would leave their homes and businesses and head for the fire. Most calls involved blazes in brooder houses, where ranchers used small heaters to keep chickens warm, though grass and orchard fires and burning eucalyptus trees also confronted local firefighters.

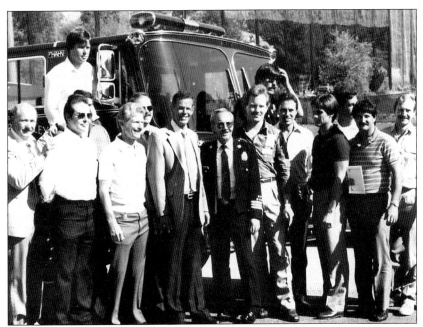

BOBBY UNSER AND VALLEY FIREMEN. In 1986, Bobby Unser, three-time champion of the Indianapolis 500 and son of Castro Valley's first fire chief, Jerry Unser, came to the valley and is pictured at center, next to Castro Valley's last fire chief, Bob Waberski. Because Jerry played such an important part in organizing the area's first department in the 1920s, this last department dedicated their new truck to him.

1915 SEAGRAVE 750 G.P.M. In 1973, the Castro Valley Fire Department (CVFD) purchased this vintage Seagrave fire truck for $1,000. The truck actually belonged to the San Luis Obispo Fire Department first, before Harrah's Casino in Reno bought it to be parted out for use in displays. The Seagrave was destined for the scrap heap when the CVFD's Norbert Hudak (center) and John Colagross (loading truck) salvaged it.

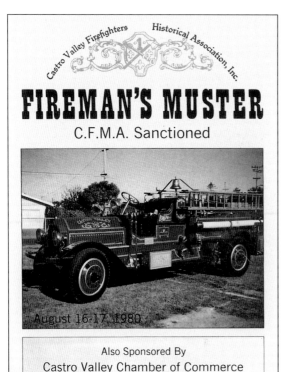

FIREMAN'S MUSTER

C.F.M.A. Sanctioned

August 16-17, 1980

Also Sponsored By
Castro Valley Chamber of Commerce

FIREMEN'S PRIDE AND JOY. This 1980 publication from the Castro Valley Firefighter's Historical Association, Inc. and the Castro Valley Chamber of Commerce detailed the Seagrave's saga, and loving restoration, over the course of several years. The grand old engine can still be seen at least once every year in the Rowell Ranch Rodeo Parade.

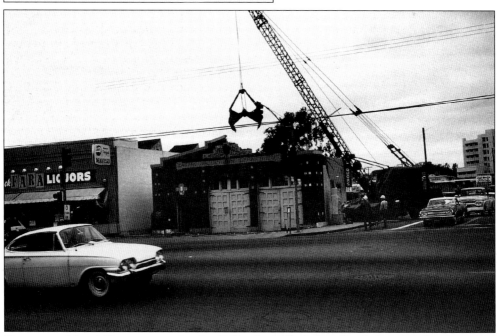

FIREHOUSE NO. 1 DEMOLISHED. In the 1960s, the valley's first fire department headquarters, which stood on the Boulevard, was demolished to widen the entrance to Lake Chabot Road. The historic brick building was in the heart of the old town business district, surrounded by some of the valley's oldest commercial structures.

Six

THE MODERN VALLEY
1960–PRESENT

The end of the 20th century was a time of transition for Castro Valley. Residential subdivisions became the dominant feature of the landscape, modern shopping malls replaced many of the familiar businesses along the Boulevard, and the valley's "splendid isolation" was finally broken by the construction of Interstate 580 and the Castro Valley BART station.

The old tried to keep up with the new. The California State Hatchery, once a symbol of the local poultry industry, converted to a pet shop. Retailers at the Village came and went, but shoppers continued to support a real Western boot shop. Commuters towed their imports to an auto shop, which once serviced Oldsmobiles and Edsels, while contemplating the repair bill at a deli enjoyed by three generations of valley residents. Hikers continued to enjoy the trails around Lake Chabot. Citizens saved the old Stanton and Strobridge Houses, restored their beloved Chabot Theater, and broke ground on a new center for the arts. Much of the old survived with the new, and the community shared their love for its past with a faith in its future.

Incorporation was, and remains, the most controversial issue for valley residents. Proponents argue for greater control, while opponents counter with warnings of additional taxation. The debate goes on. Yet, regardless of the path they ultimately choose, the same undaunted spirit that replaced Zachariah Hughes's little schoolhouse after it was wheeled off in the night will continue to guide Castro Valley's future.

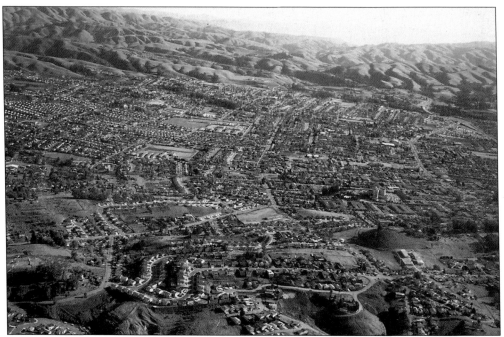

THE VALLEY IN 1960. This 1960 aerial, looking west to east, illustrates the amount of growth that the valley experienced in the preceding two decades. Very few open spaces or ranches are visible by this time, and even the canyons and foothills are beginning to be overtaken by the sprawl of tract housing.

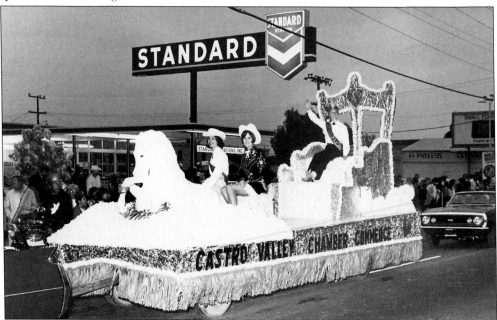

CAMAROS AND CADILLACS. Castro Valley, like the rest of the nation, experienced great economic and social change during the 1960s and 1970s, not least of which was the 1973 oil crisis. This scene seems to be a sign of things to come, as a lavishly decorated chamber of commerce float is pulled past a glowing gas station sign by a powerful 1960s gas guzzler.

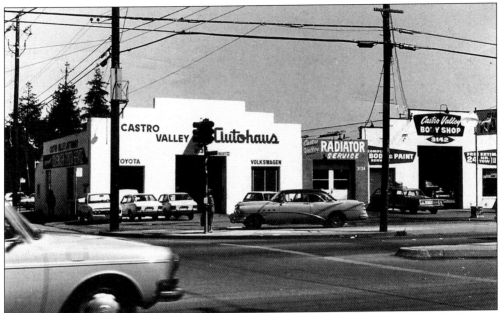

THE AUTOHAUS. A longtime Castro Valley staple, the Autohaus, still stands on Park Way and San Carlos Avenue today. Like other Americans, valley residents eventually began to downsize their vehicles of choice, however reluctantly, as gas prices continued to increase in the 1970s. The Autohaus specialized in both Japanese and small European import cars, which became popular because of their reputation for excellent gasoline economy.

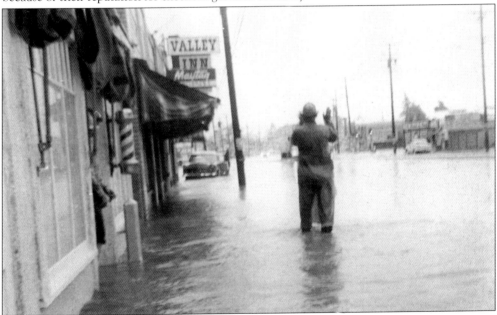

FLOODING. In winter of 1962–1963, torrential rains submerged Castro Valley's lower-lying areas in at least six inches of water. Though the city rarely receives enough rain each year for this to be routinely problematic, the lower valley is actually on a flood plain. It later became mandatory for all new construction on the Boulevard to account for the risk. This explains the raised foundation of the new Starbucks on Lake Chabot and the Boulevard.

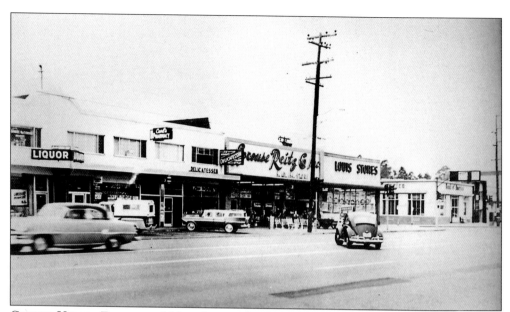

CASTRO VALLEY FAVORITE. Although many businesses on the Boulevard could not stand the test of time, Lucca's Deli, pictured here in the center of the block, has been the favored lunch spot of more than three generations of Castro Valleyians. Renowned for their hearty subs and imported Italian goods, non-locals might miss the small storefront completely. Many prefer it that way, though, and keep it a closely guarded local secret.

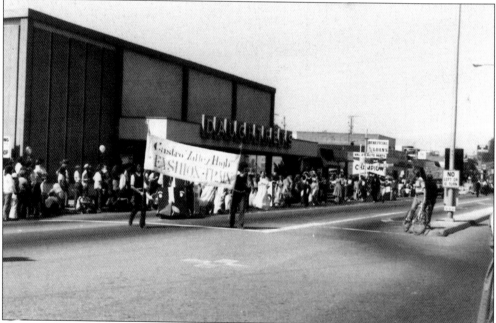

DAUGHTREY'S. Even some of the most popular businesses in the area are only fond memories today, as is the case with Daughtrey's Department Store, which stood across from the Castro Village for many years. Residents remember the store as one of a dying breed of retail establishments, where an established sales staff knew the names of customers and kept up with their families' needs as they grew through the years.

DOWNTOWN SHOPPING AND RURAL REQUIREMENTS. This photograph of the village from the late 1960s illustrates that, although Castro Valley had become thoroughly modern and suburban in many ways, there was still enough rural residents to support a boot shop in the middle of the downtown shopping area.

CHANGING NEEDS. One of the most notable social changes in the nation during the 1960s and 1970s was a growing health-consciousness and emphasis on natural and organic foods. It is no surprise then, that another Castro Valley favorite, Village Foods, opened its doors for the first time in the 1960s. The small, friendly grocery store still has a loyal customer base today, specializing in natural foods and vitamins.

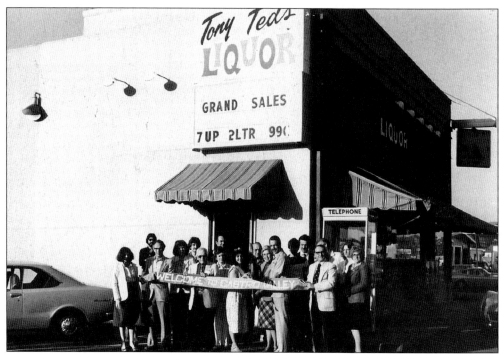

GROWING COMMERCE, CONSISTENT TASTES. With business still booming, Fara Liquors, one of Castro Valley's oldest establishments, was able to expand in the 1970s to a larger location where the old Safeway had stood. Tony and Ted's Liquor, still at the corner of Lake Chabot Road and the Boulevard today, proved that while the city had come a long way from its bootlegging days, its thirst has remained consistent.

THE OLD HATCHERY. While the transformation of some businesses along the Boulevard have been abrupt and others uncertain, the 1962 transition of the California State Hatchery to the Pet Center was a natural evolution. The Lorge family, who kept the hatchery prospering for years, adapted the business to fit the needs of the valley's new residents, who were mostly families with young children and pets.

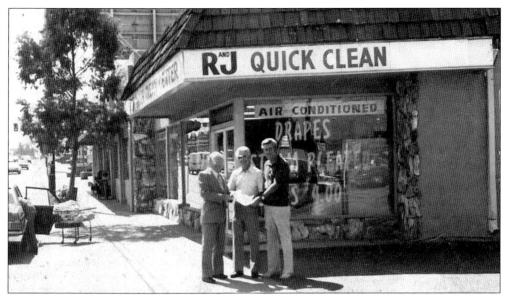

R&J QUICK CLEAN. A Castro Valley establishment in their own right, the Lorge family was one of the very first business owners in the area. In 1962, the same year that the Lorges transformed the Hatchery into the Pet Center, they also opened a new business next door, the R&J Quick Clean. Pictured here, from left to right, are Bob Cooper, Ray Lorge, and Jim Lorge.

NEIGHBORHOOD CHURCH. In the 1960s, Neighborhood Church, formerly of Oakland, began construction on their new facility in Castro Valley, removing thousands of tons of soil to level the hillside site. The developers of the new Oakland Coliseum saved the church great expense by utilizing this fill for their own project, though Castro Valley residents complained that removing so much dirt from the Valley's western ridge would let more fog in.

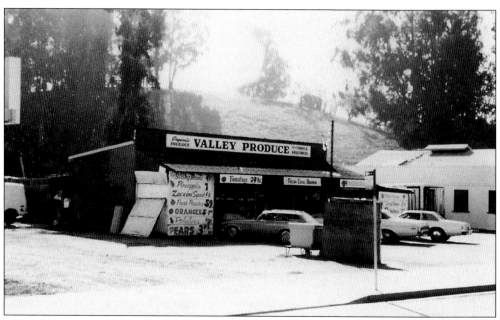

VALLEY PRODUCE. The Valley Produce stand was one of several markets in the city during the 1970s specializing in fresh seasonal fruits and vegetables. The location changed proprietors several times before becoming Carrows restaurant. In June 2005, residents of the valley were once again able to purchase fresh produce locally, as the long-awaited, much-anticipated Castro Valley Farmers Market finally opened.

GOLDEN TEE'S DRAGONS. These three charming dragons have welcomed folks to old town since the 1960s when Golden Tee Golfland was first constructed, and the secret they keep has been in Castro Valley's lore nearly as long. The previous owners of the property had a steel, walk-in safe so large that they could not afford to have it moved, so the dragons' volcanic home was built right on top of it.

120

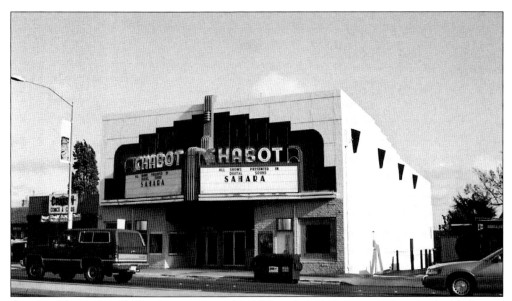

CHABOT THEATER. Chabot Cinema opened in 1951, with 200 guests attending the double feature premier of *Willie Comes Marching Home* and the *Nevadan*. The 600-seat theater was established through a partnership of Chabot Realty, Bank of America, and builder Kenneth Ruggs. A proud city landmark, the theater is an important symbol of downtown's revitalization, and the success of its recent restoration bodes well for commerce in the valley.

INCORPORATION MEETING. Since developing its own awareness as a distinct community, Castro Valley has tried, and failed, to incorporate as an official government entity countless times. Yet each time residents reject incorporation, they reinforce their city's atypical identity, and many are proud of its independent status. At an incorporation meeting in the early 1970s, local citizens try not to look like they've heard it all before.

THE REAL ESTATE BUILDING. Real estate, and the ownership and redistribution thereof, has always been a central factor in Castro Valley's long-running debate on whether or not to incorporate. In the most recent deliberation, however, it wasn't the acreage or boundaries of the town itself, but the appearance of the property agents' headquarters that drew the most fire. Built at the site of the old L&W Drive-In, this real estate building produced a few shakes of its own during its construction. Castro Valley happened to be in the midst of yet another incorporation effort in 2002, with one side arguing against the creation of another layer of government and the other arguing for greater control over government, by establishing a city council in place of the county-run Municipal Advisory Committee (MAC). When it was found that the original MAC-approved plans for this structure did not match the end result, both sides of the incorporation debate managed to use the bureaucratic discrepancy as validation of their respective point of view. Nearly 75 percent of Castro Valley voted against incorporation in 2002.

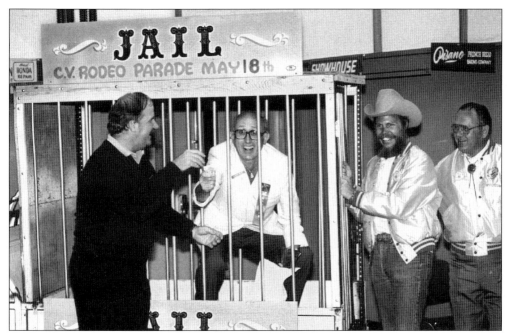

THE CHAMBER OF COMMERCE. Although Castro Valley does not have an official city council, the chamber of commerce has been an active and positive influence on local business since its establishment in 1937. Some members of the chamber are pictured here, clowning around and having fun with some of the folks from the Rowell Ranch Rodeo during their annual parade, which always features many members of the business community.

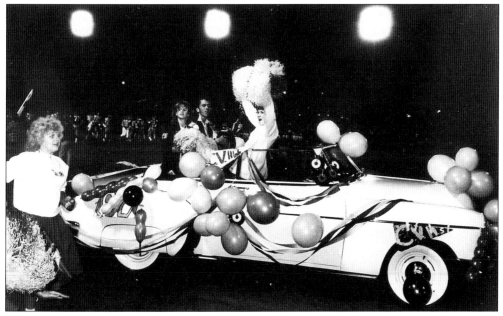

HOMECOMING PARADE. Every year since 1956, through every fall, winter, and spring, the city fills with the celebratory sounds of youth as students from Castro Valley High School participate in annual dances, rallies, and sporting events. This photograph was taken at the 1984 homecoming rally in the school's main stadium.

CENTER FOR THE ARTS. Pictured here is the architectural rendering of Castro Valley High School's new center for the arts, which will feature the city's first fully equipped theater. Castro Valley residents chose to support the high school's arts and music program at a time when many school districts across the country have been forced to cut them, ensuring a well-rounded education for local children.

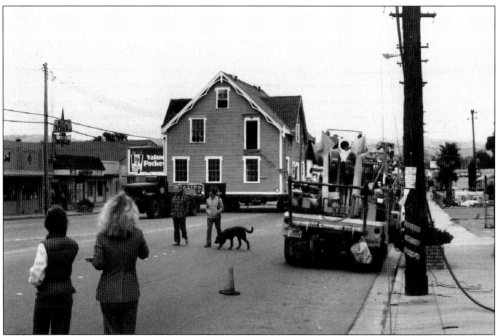

SAVING THE STANTON HOUSE. In 1978, Dan Duggan and Dennis McDonald bought the Stanton House for $1 and committed $250,000 to convert the aging structure into a law office. However, the house was forced from its original site across from Eden Hospital, and finding a new location was difficult. Thanks to the efforts of Duggan, McDonald, and the Castro Valley Chamber of Commerce, the beautiful old house was saved.

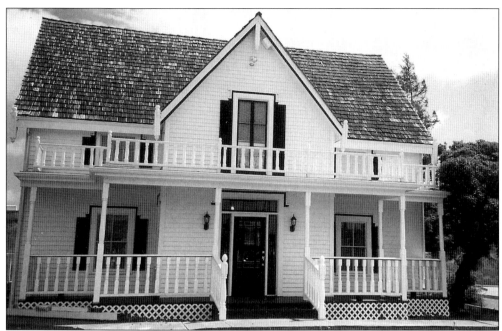

STANTON HOUSE TODAY. Now a fully integrated part of the downtown business district, the Stanton House has been rented out as office space since its restoration was completed. Most Castro Valley folks delight in the mix of old and new architecture around town, and many will wryly inform inquiring minds that this historic home is located between a McDonald's and a freeway off-ramp.

E. K.'S PLACE. E. K. Strobridge, son of James Harvey, lived in this area most of his life and eventually became a state senator, residing in this home whenever he returned to Castro Valley. Unfortunately the house, which was originally purchased from A. F. Herrick, fell into disuse and disrepair over the course of its long life, and was barely saved from demolition in the 1990s.

STROBRIDGE HOME TODAY. This rare survivor of 19th-century Queen Anne–style architecture, the Strobridge House was once referred to as Hayward's most beautiful home, again associating Castro Valley's close relationship to the town across the San Lorenzo Creek. Built originally for John Herrick in 1906, the house was later sold to E. K. Strobridge and moved from Redwood Road to Strobridge Avenue, and then in 1946 to William Street. There it served as Stivers Nursery School for 42 years, until local citizens attempted to convert the house into a museum. Although a lack of funding prevented the establishment of a museum in the home, its structure was preserved as part of the affordable housing complex near Norbridge and Redwood Roads. As Castro Valley looks forward to new changes and prosperity in the 21st century, cherished landmarks like this will always remind the community of its rich heritage, while facilitating a brighter future.

ALCORN PROPERTY. Another example of Castro Valley's constant battle between preservation and growth, this chicken ranch situated between Seven Hills Road and Malabar Avenue is perhaps the very last of its kind in the area, and is now threatened by development. The late George Alcorn paid his way through University of California, Berkeley by delivering eggs from his ranch to East Bay restaurants. He went on to become a pioneer in poultry industry technology and head of the University of California Agricultural Extension. The Alcorns now plan to develop the property, though neighbors have engaged them in a lengthy struggle to preserve the homestead as an historical park, securing funding from several historical organizations and the parks and recreational districts. It seems for every story of preservation in Castro Valley, there are as many of demolition, subdivision, and sprawl. The outcome remains uncertain, but neighbors remain hopeful that they may someday be able to create a place for the whole community to experience a time, not so long ago, when chicken was king in Castro Valley.

THE OTHER CASTRO VALLEY SIGN. In 1997, the Alameda County Art Commission hired artist Sheila Klein to design a welcome sign for the new millennium, incorporating the charisma and character of present-day Castro Valley without neglecting the richness of its past. The vibrant yellows and greens of the sign matched the colors of the valley's seasonally changing hills, while the bands of metal that formed the arch were made to resemble an Ohlone tule canoe (see page 10). The word "Welcome" even featured a fine, perforated line winding through the center of each letter, reminiscent of the bright yellow center lines of Castro Valley's many roads as they meander in and out of the canyons and over the hills. Whether or not the valley's most vocal residents appreciated the craftsmanship, they did not approve of the unorthodox appearance, and after a Bay Area radio station encouraged listeners to vandalize the sign, it was removed. No one has dared initiate a new sign since, and Castro Valley remains one of the largest communities in the country without official governmental, or even visual, demarcations.